ROLAND REISS

TO MY DEAR FRIEND
CINDY WITH BEST
WISHES —

Roland

Itinerary of the Exhibition

19 November, 1991 to **19 January, 1992**	Los Angeles Municipal Art Gallery Barnsdall Park, Los Angeles, CA
16 February, 1992 to **29 March, 1992**	University of Arizona Museum of Art Tucson, AZ
21 June, 1992 to **13 September, 1992**	The Newberger Museum of Art State University of New York at Purchase Purchase, NY
6 November, 1992 to **3 January, 1993**	Palm Springs Desert Museum Palm Springs, CA

ROLAND REISS

Curated and Edited by

BETTY ANN BROWN

Essays by

BETTY ANN BROWN

MERLE SCHIPPER

BUZZ SPECTOR

RICHARD SMITH

ROBERT DAWIDOFF

A
Seventeen
Year
Survey

*Initiated
and sponsored
by the
Fellows of
Contemporary Art
and organized
by the
Los Angeles
Municipal Art Gallery*

Cover Detail F/X: Flaming Hearts

Published by the Fellows of Contemporary Art
520 South Grand Avenue, Seventh Floor, Los Angeles,
California 90071.

Library of Congress Catalog Card Number 91–73980
ISBN 0–911291–19–9

2400 copies printed on the occasion of the exhibition, "Roland Reiss: A Seventeen Year Survey"

Contents

Director's Forward

EDWARD LEFFINGWELL, DIRECTOR OF VISUAL ARTS
LOS ANGELES MUNICIPAL ART GALLERY

The *mise en scène* of Roland Reiss' sculptural opera invites participation by means of narrative tableaus the artist intends us to read and populate, rather than simply observe. It is possible to understand the stopped-time nature of these "sets" as temporarily frozen moments that allow the viewer to enter—in the manner that Alice passes through the Looking Glass—a narrative world in progress and become, in a sense, co-creator of that world. Although the elements of these interiors are often altered in scale, they are not fetishized as individual totems or relics which derive authority by "anthropological" association, and they are not accumulations of fabricated props that exist primarily to be photographed. Although Reiss manipulates the material relationship of the viewer to the object, and of objects to each other, his primary commitment is to an understanding, through presentation, of the content: the desired or implied meaning of how and why things happen, the meaning of those relationships in Western culture, and how we are implicated in their construction.

Wherever his work appears, an invitation to personal and architectural association is part of the play, the dance of the work. The elongated box-like structure of the Los Angeles Municipal Art Gallery, where this important presentation of Roland Reiss' work originates, is almost ideally suited to its installation—a kind of mirror enlargement of the basic confines of a Reiss tableau. It is equally appropriate that the Gallery has committed to the administration and installation of this project, considering the Gallery's dedication to the exhibition of the work of artists of the Los Angeles area. That mission includes an understanding that the artist of Los Angeles is an artist in the world, and the traveling of this exhibition emphasizes that view.

The Municipal Art Gallery is privileged to participate in the origination of this ambitious project, which was proposed to the Gallery in 1988 by the Fellows of Contemporary Art. Together, we began a search for a curator who could bring to bear an intelligence and sensitivity to Reiss' work that would illuminate its selection and documentation. We were fortunate in securing the professional commitment and dedication of the exhibition's curator, Betty Ann Brown.

Without the generosity of time the artist and curator bring to this project and the Fellows' strength of purpose and the financial support necessary to realize not only the initial presentation, but to underwrite its documentation and tour, this exhibition would not have been possible.

Betty Ann Brown's essay exists on both a scholarly and an interpretive level, providing an understanding that is compatible with the artist's intentions. Working with Roland Reiss, she has constructed a means of selection that is, perhaps, definitive, within the considerable possibilities that were available. As a result of this selection process, we are able to enter the work and recognize a full range of the artist's investigations. The critical thought and awareness brought to this interpretation by Brown's selection of guest essayists broaden and intensify our ability to enter into the exhibition through the catalog.

We are grateful to the artist Roland Reiss, curator Betty Ann Brown, and essayists Robert Dawidoff, Merle Schipper, Richard Smith and Buzz Spector. In a time of diminished support for the arts, the Municipal Art Gallery is particularly obliged to the Fellows of Contemporary Art for its singular dedication to the presentation and documentation of this

prodigious body of work; to Fellows' liaison Peggy Phelps and to Administrative Director Alice Rotter. Staff curator Noel Korten has been of invaluable service, acting as liaison with the Fellows, the artist and the curator. Chief preparator Michael Miller and the Gallery's preparation staff have been thoroughly engaged in the possibilities of the exhibition's installation. The Municipal Art Gallery acknowledges with pleasure the design service brought to this catalog by Eileen Avery, and applauds the enthusiastic reception of those institutions participating in the exhibition's tour.

The Municipal Art Gallery, a facility of the Cultural Affairs Department of the City of Los Angeles, also acknowledges its debt to the citizens of Los Angeles, who provide the financial base and audience for its programs, and recalls the ongoing commitment of the Directors of the Gallery at Barnsdall Art Park and the Los Angeles Municipal Art Gallery Associates.

Sponsor's Forward

VIRGINIA C. KRUEGER, CHAIRMAN
FELLOWS OF CONTEMPORARY ART

It is with pleasure that the Fellows of Contemporary Art presents ROLAND REISS: A SEVENTEEN YEAR SURVEY.

Many of our members have been familiar with Roland's work for a number of years, and we are delighted to bring it to a wider audience.

Since the Fellows was established in 1975, our organization has sponsored twenty exhibitions featuring the work of emerging and mid-career California artists. Each exhibition has been documented by a scholarly catalog, and more recently by a videotape.

We are extremely pleased to hold this exhibition at the Los Angeles Municipal Art Gallery. We worked with the Municipal Gallery in 1984 to sponsor a Martha Alf exhibition and are happy to return to the space for ROLAND REISS: A SEVENTEEN YEAR SURVEY. We would like to thank Betty Ann Brown for her curatorial expertise and for arranging the travel for the exhibition. Thanks also to Edward Leffingwell, Director of the Los Angeles Municipal Art Gallery, and Noel Korten, Gallery Curator, who have both worked closely with us to assure the success of this show. We are grateful to Roland Reiss for his continuing devotion to artmaking and for his enthusiastic collaboration on this project.

This exhibition will be traveling to the University of Arizona Museum of Art, The Newberger Museum of Art at State University of New York at Purchase and the Palm Springs Desert Museum. We thank the directors of these institutions for their support of the Roland Reiss exhibition.

We would like to thank Peggy Phelps, Fellows' liaison to the exhibition, and Fellow Kathy Reges for her assistance with the show. Special thanks to the 173 members of the Fellows of Contemporary Art, whose contributions and dedication to the support of contemporary California art have made this exhibition possible.

"The artist discovers at the deeper level of the expression-

continuum a new system of relations that the preceding

segmentation of that continuum, giving rise to an expression

form, had never made pertinent."

Umberto Eco
A Theory of Semiotics [1]

Roland Reiss, Art & Life

BY BETTY ANN BROWN

When Umberto Eco, the famed Italian professor of semiotics, decided to turn his hand to creative endeavors, he chose to write murder mysteries (*The Name of the Rose* [1984], *Foucault's Pendulum* [1988]). This is not surprising. One of the main foci of semiotics is the analysis of indexical signs—the "clues" for deciphering cultural meaning. Similarly, when artist Roland Reiss began to use miniature sculptural tableaus to interpret the myths of modern life, he began with two murder mysteries whose "clues" were analogs for the significant objects with which we define and identify ourselves. A cowboy hat and rangy boots indicated the protagonist; his self-consciousness was made manifest by sets of flood lights ostensibly illuminating his actions; horoscope readings printed on tiny sheets of plastic revealed his (and other characters') search for meaning. The murder mystery tableaus were radical, if not shocking, at the time because they so rapidly, indeed abruptly, made the shift from modernist pursuits to those of postmodernism, from the minimalism that dominated sculpture in the early 1970s to the fractured, decentered narrative that is the basis of so much critical concern today.

This exhibition is a survey of Reiss' oeuvre from the "Murder Mysteries" and "Philosophical Homilies" created in 1974–75, through the most recent work of 1991. Although the work is consistent in its rigorous theoretical conception and technical exactitude, it varies immensely in scale and content.

The variations in Reiss' work reflect the vicissitudes of his twentieth century life.[2] Reiss was born in Chicago, Illinois. He was a child of the Great Depression, and his father's anxiety about viable employment ultimately led the young Reiss to choose a career in art. The family moved to Pomona, a small community due east of Los Angeles, in 1943.

As a child, Reiss developed interests in both writing and art. He remembers that his two junior high school English teachers were particularly encouraging. But when Reiss went home to tell his father that he had decided to go on to college to become a writer, he was told that he was, instead, to go to work after high school to earn money. His English teachers had no response to such parental proscriptions, but his art teacher urged him to go on to art school to become a commercial artist and thereby earn a good income. The young Reiss decided on art, although the construction of narrative remained a major issue in his work.[3]

By high school, Reiss was the class artist. He remembers that his first oil painting (of the sun setting behind a pagoda in the beachside community of Corona del Mar) required him to construct an elaborate architectural model, which he did alone at home. After high school, Reiss moved to Chicago where he secured a job at Bielefeld Studios as an apprentice, making deliveries and occasionally doing illustrations. He took classes at the American Academy at night and when his $18 a week salary proved inadequate to the tuition, his painting instructor allowed him to continue the class without paying. This was but one of many instances in which Reiss experienced notable generosity from authority figures in the art world. The owner of Bielefeld also befriended him and eventually urged him to return to California, where he could attend a junior college at no charge. By 1949, Reiss was enrolled in Mount San Antonio Junior College and was working for the Los Angeles County Fair, designing dioramas and educational displays. Like the early painting model, these dioramas anticipate, or form conceptual archetypes for, the artist's mature oeuvre.

Reiss was drafted in the early 1950s but instead of doing combat in Korea, he painted murals. His theatrical backdrop in front of which the general addressed new troops—a mural which Reiss describes as "pure Norman Rockwell in style"—won the artist a commendation. Later, a painting of Southern California's Mount Baldy won him a prize and another reprieve from overseas duty. Light-and-space artist Robert Irwin was also a prize-winner, but the two did not meet at that time.

Reiss attended the University of California at Los Angeles (UCLA) on the G.I. Bill and studied art with Stanton MacDonald Wright, Jan Stussy, Sam Amato, Clinton Adams and William Brice. While at UCLA, Reiss worked for a while as painter Rico Lebrun's assistant. He received his Master of Arts degree in 1957 and took a job teaching painting at the University of Colorado in Boulder. Reiss had married just before entering UCLA. By the end of his tenure at Boulder, he and his wife Betty Reiss had six children. Reiss considered the University of Colorado Art Department "a great place"[4] and knows that he benefited tremendously from his time there. For example, when the venerable abstract expressionist painter Clifford Still came to be artist in residence, the two developed a special relationship.

Reiss had been deeply impressed by Still's paintings when, as a graduate student, he saw them exhibited in San Francisco. "I felt I was looking at the brain of a person pressed flat, at the map of an entire mind." Then, in the summer of 1965, as the two artists sat over coffee morning after morning, Reiss was exposed to what he now calls "one of the most revolutionary thinkers I've ever encountered." Reiss respected Still's sense of history and shared with him a deep, moving conviction about art. To this day, Reiss asserts that one knows through seeing, that the psychological aspects of perception are crucial, and that art has the power to affect human actions. He finds support for these beliefs in the writings of German aesthetician Conrad Fielder, who holds that "art has been, and still is, the essential instrument in the development of human consciousness. The significance of art … lies in the fact that it is the particular form of activity by which man not only tries to bring the visible world into his consciousness, but even is forced to the attempt by his very nature." The artistic activity, Fiedler insists, is not fortuitous, but necessary.[5]

When he arrived in Boulder, Reiss was doing semi-abstract landscape paintings that owed a lot to Abstract Expressionism. As the artist says, "The route I was on was one of progressively reductionist abstraction." Reiss' was the kind of modernist activity that T. J. Clark, in critiquing Clement Greenberg's formalist theory, alludes to as the "practice of negation."

"Modernism is certainly that art which insists on its medium and says that meaning can henceforth only be found in *practice*. But the practice in question is extraordinary and desperate: it presents itself as a work of interminable and absolute decomposition, a work which is always pushing 'medium' to its limits—to its ending—to the point where it breaks or evaporates or turns back into mere unworked material. That is the form in which medium is retrieved or reinvented: the fact of Art, in modernism, is the fact of *negation*."[6]

The Ball Game
Installation Detail

The "practice of negation" began to ring hollow for Reiss by the late 1960s, a decade before critics like Clark began to challenge the Greenbergian foundation of modernism.

Reiss was given a retrospective of this work at the Denver Center in 1969. But when he stood in the exhibition, surrounded by over 25 of his works, he had "a terrible feeling of disappointment." Later, he began to understand the reasons for the let-down: "I'd built this great edifice of rationalizations to support the work, but I'd never thought out the real

. . he began with two murder mysteries

whose "clues" were analogs for the

significant objects with which we define

and identify ourselves.

connections between experimentalism and content. I thought that when I saw the work in the retrospective, all of my life would come back to me. After all, I'd sacrificed a lot, and I'd always meant for this work to absorb the totality of my experience. I thought my whole life would be up there on the gallery walls, but it wasn't. My minimalist paintings were part of an art movement I'd participated in, a mainstream activity, but not necessarily me at all. I had to do something, I had to change my work." Other factors were operating. Conceptualism was a rising current in the art world. German artist/activist Joseph Beuys had done a piece called "The Chief: Fluxus Song" (Rene Block Gallery, Berlin, December 1, 1964) in which he rolled up in felt and made strange sounds. Reiss was stunned; he asked himself, "Am I free to do that? Can I change?" And Reiss' personal life was in crisis. His family was in difficulty. He was turning 40. His marriage was breaking down.

In spite of all the positive experiences in Colorado, Reiss always felt there was a wall between himself and the ocean. He constantly talked about going back to California. He felt increasingly compelled to return. "I felt like there had been a veil over everything. Then the veil began to lift. For the first time, I began to value my life and see it was real."

After the retrospective, Reiss turned his artistic eye to the social environment, to the psychology of human relationships. In short, he moved from Greenbergian modernist formalism to postmodernism, where content—and its critical restructuring—mattered again. He was not interested in academic figuration, because he viewed the eclectic recycling of Renaissance models as an incestuous historical game, a game which he did not want to play. This kind of academic figuration is what Fiedler calls "modern mannerism," and which he judges a non-artistic process, based solely on conceptual activity.[7] Reiss knew his work had to be fresh, part of his contemporary experience, so he looked to European filmmakers Bergman and Fellini for inspiration.[8] He decided to begin with the figure, to make the human figure the measure of all things. And he decided to use figures that were only a few inches high. "It's the painter's mentality," he explains. "In the same space, I can draw my thumb or the whole galaxy. In order to get big, you go small in a painting. Cezanne's Mount Sainte Victoire is only inches high."

Reiss' determination to change his art and his life led him to take the position of Chair of the Department of Art at Claremont Graduate School, and, ultimately, to the murder mysteries in 1975. Drawing inspiration from Eco's *Theory of Semiotics* (first published in English in 1974), from the foreign films he had screened in Colorado, and from the new view of autobiography engendered by the feminist art movement, he began to create a world of content, of subject matter. He moved from art about light and space and perception into art about human experience.

Reiss began by taking the casting techniques he'd mastered with the abstract work and using them to create hundreds of small figures. "There is something magical about it," the artist explains. "You create a cavity, pour a liquid into it, the liquid hardens and it emerges as something with recognition value. And I learned from the casting process how you can control the recognition value. You create a duck, a mallard duck, or Donald Duck.[9] 'Amuse and Amaze' is a run of different sets of objects, a mixture of codes related to elements found in everyday life. That's truly visual language, the stuff with which artists work."[10] It is also the essence of semiotics.[11]

Because the casting lent itself to multiples, Reiss began to address the meaning of series, "to the hypnotic spell of staccato, numerical repetition." He cast hundreds of collie dogs, lined them up in rows, and began to consider the way he might regard them. The issue of "sight plane" became important: at which distance did the objects appear "real," that is, to scale … and when did the viewer break through that plane and suddenly become a giant? This question forced Reiss to grapple with Heisenberg's Uncertainty Principle—that the measurement (and thus the understanding) of anything is tainted by the perceiver, and by the position in time and space of the perceiver—a concept discussed in cultural terms by Terence Hawkes: "Every perceiver's method of perceiving can be shown to contain an inherent bias which affects what is perceived to a significant degree. A wholly objective perception of individual entities is therefore not possible; any observer is bound to *create* something out of what he observes." [12]

Reiss began to question how the perceiver relates to small scale things, how the perceiver begins to project her/himself into the piece … which led him to contemplate children and their relationship to doll houses. Reiss realized that the miniatures he was creating were set up to cue all kinds of ideas, that he had come upon a system for presenting and inducing the analysis of indexical signs.

French anthropologist and structuralist theorist Claude Lévi-Strauss clarifies the meaning and efficacy of miniatures:

"What is the virtue of reduction either of scale or in the number of properties? It seems to result from a sort of reversal in the process of understanding. To understand a real object in its totality we always tend to work from its parts. The resistance it offers us is overcome by dividing it. Reduction in scale reverses this situation. Being smaller, the object as a whole seems less formidable. By being quantitatively diminished, it seems to us qualitatively simplified. More exactly, this quantitative transposition extends and diversifies our power over a homologue of the thing, and by means of it the latter can be grasped, assessed and apprehended at a glance.

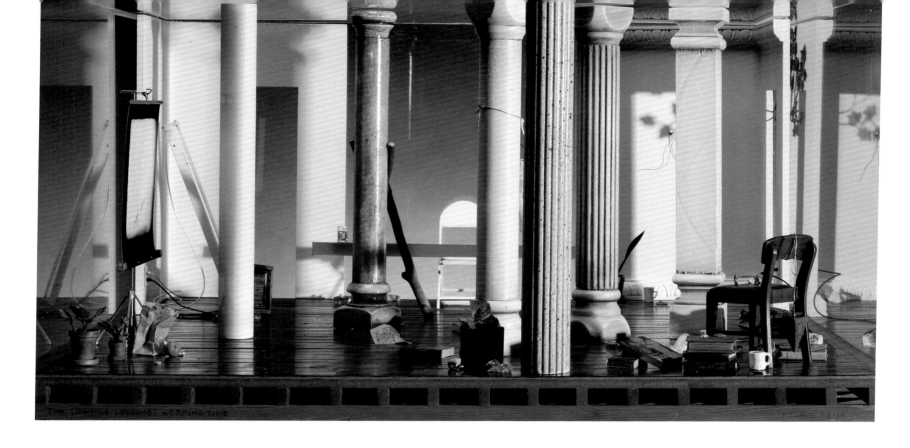

The Dancing Lessons: Keeping Time

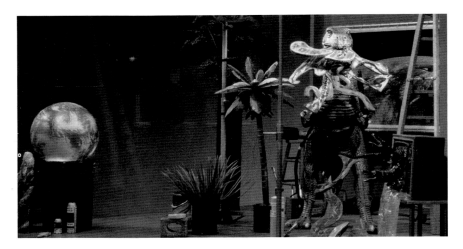

A child's doll is no longer an enemy, a rival or even an interlocutor. In it and through it a person is made into a subject. In the case of miniatures, in contrast to what happens when we try to understand an object or living creature of real dimensions, knowledge of the whole precedes knowledge of the parts. And even if this is an illusion, the point of the procedure is to create or sustain the illusion, which gratifies the intelligence and gives rise to a sense of pleasure which can already be called aesthetic on these grounds alone."[13]

Yet another concept was involved. Throughout his teaching, Reiss has dealt with what he terms "plateauing," that is, the stratifying of ideas as presented in a particular theme or subject. He urges his students to find correspondences that drop through various interpretive layers, to practice a sort of intellectual archaeology. A model for "plateauing" is Shakespeare, who was of course a master at establishing multiple layers of interconnected thematic materials. Reiss realizes that, as Jurgen Habermas asserts, the aesthetic experience is never limited to one perceptual arena.

"The aesthetic experience then not only renews the interpretation of our needs in whose light we perceive the world. It permeates as well our cognitive significations and our normative expectations and changes the manner in which all these moments refer to one another."[14]

Reiss has said that he considers himself no more than a medium, a channel for the zeitgeist. "I am part of a larger group mind, even if I do have an individual focus. I don't have any truths to give people, don't know anything anyone else doesn't. But I have what everyone else has —I can share my daily experience. Art is about existence." In thus denying the primacy or even the possibility of originality, Reiss joins such postmodern thinkers as Roland Barthes, whose work (to quote Rosalind Krauss) "is a demonstration of the way that systems of connotation, stereotype, cliche, gnomic utterance—in short [the way] the always already-known, already-experienced, already-given-within-a-culture— concatenate to produce a text."[15]

As Reiss constructs the narrative layers of his works, as he isolates and opposes the various cultural codes he is exploring, he presents viewers with an informed reading of the meaning of experience, and of how they and their material surroundings are situated in the ideological construct. Because this may all sound painfully intellectual, it should be asserted that

Reiss is above all an accessible artist. "Once you conceive of yourself as a medium, you realize that what you do has to become more immediately accessible," he asserts. Reiss' tableaus are seductive, amusing models of human behavior—even as they analyze that very subject critically. This derives from Reiss' conscious layering of content: a five-year-old boy is immediately engaged by the "F/X" tableau which "stars" Godzilla (1990–91). His mother, also initially drawn in by curiosity, is forced to consider the technology of entertainment and, from that, how Hollywood and the media pictorialize and encapsulate our values.

"I am part of a larger group mind, even if

I do have an individual focus. I don't

have any truths to give people, don't know

anything anyone else doesn't."

Typical of postmodern art, however, Reiss' narrative constructions are neither set nor linear. While much Italian Renaissance art, for example, might be said to "illustrate" or at least pictorialize the culturally shared text of the Bible, and specifically to pictorialize that text according to interpretations set by various papal councils, Reiss' works counter the very possibility of a fixed text or reading. Lisa Tickner might have been talking about Reiss' work when she wrote (in reference to an exhibition of five British artists): "There are narrative fragments but there is no linear coherence. We are encouraged to read vertically, through association, across the relations of text to image, along the terms of the primary processes of condensation and displacement. No longer consumers at the margin of a finished work, we are drawn onto the site [in Reiss' work, the site is literally constructed for us] and onto the process of meaning itself…The work of these artists employs and relates to narrative, but it does so in order to deconstruct the 'fictions of coherence'…It uses fragments of narrative—or the ingredients for a narrative or particular narrative devices—in opposition to a modernist elimination of content in the image."[16] In spite of the extraordinarily well observed detail in Reiss' works, neither the narrative line nor the outcome is predicated by the artist. Viewers must *create* (and here we refer back to Hawkes) their own resolutions—or lack thereof—in response to each of Reiss' tableaus.

It was fascination with the media presentation of a University of Colorado campus murder that inspired Reiss to create the first murder mystery tableau ("Easy Turns, Happy Trails: A Murder Mystery," 1975). He remembers reading various newspaper accounts and juxtaposing them with television coverage, then with the information from campus insiders. He watched the development of schematic drawings of the scene of the crime, watched how the revelation of various clues induced alternative hypothetical solutions.

In a small plexiglass box, using tiny forms cast and constructed in his studio, he began to choreograph his own version of the murder—or rather, of the murder of the artistic muse. He charted the astrological moments of the various fictional participants, gathered the diagnostic paraphernalia that would identify the dramatis personae, graphed their movements across the floor of his tableau. Again, Tickner might have been writing of Reiss' work, when she says (of Marie Yates' "The Missing Woman"): "Through visual and verbal signs, by means of characters and occurrences, we are invited to construct the identity of a woman, 'A,' [in the case of Reiss' Murder Mysteries, it is a set of characters] and encouraged to believe that by following the sequence we will be rewarded at this point of 'certainty, knowledge and truth.'…We do our best, as we do with novels, to construct the image of a whole character from the evidence we are given…But the pull towards narrative is finally refused, so that character and sequence remain elusive…and any sense of closure or equilibrium is undermined…" Tickner concludes the paragraph with a key statement: "In seeking to make sense of the images, we also work to produce a coherent position for ourselves."[17]

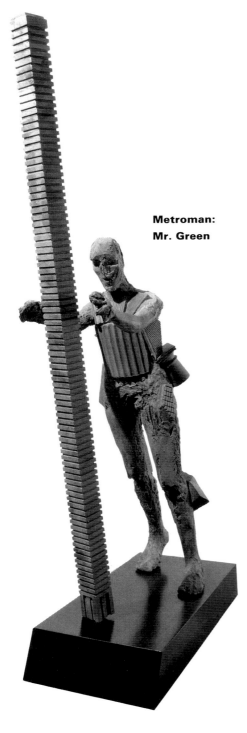

**Metroman:
Mr. Green**

It is important to Reiss that he make artworks that do not yield his intentions in a microsecond. He insists that viewers spend time with his work, that they contemplate the various plateaus of meaning. Initially, the murder mystery might seem as light a read as an Agatha Christie. But, later, the careful viewer realizes that the work also includes considered comment on the nature of the art world, and thus of the larger world.

For "Adventures in the Painted Desert: A Murder Mystery" (1975), Reiss did extensive research, including reading every past issue of *Arizona Highways* magazine available in his local library. This troubled his friends who were rooted in the Abstract Expressionist aesthetic and still believed that art issued directly from the artist's psychological interior. Reiss knew that the literary aspect of his tableaus was what made them rigorously conceptual, although at the time (again, this is the mid 1970s), the only way people could deal with the synchronic time in the work was to call it Surrealist.

"When we encounter something new or different, we apply a framework. If my work reminds someone of something — whatever it is — it is really a confirmation. When I did the 'Truth Table,' which has an image in mirror reverse, I was wondering about positive and negative space. When we send astronauts out into space, time is different for them. What happens if they get back before they start? One explanation is that reality forks.

"I did two living rooms, all out of plywood slats. I could push the slats and make the chair or sofa bend or arc, like slippage in material existence. The striations of plywood on the table form the word 'truth' (of course it's a visual pun on the mathematical and physics 'truth tables'). If you sit on one side, you read truth, on the other side, truth is backward. Anyway, I got a letter from a third grade school teacher, asking if the piece was about positive and negative universes. She really understood what I had meant! That letter was a complete confirmation of my hopes, that someone out on the streets could get it, that we're on the same wave length, share the same concerns. And the work did it visually, without elaborate texts."

Reiss' "Philosophical Homilies," the set of miniatures that paralleled the murder mysteries, is represented here by the "Truth Table," which was exhibited at the Whitney Museum in 1976, and by "Amuse and Amaze" (the piece based on everyday codes), which contrasts the insider information of the art world with that of the general public. After completing the "Philosophical Homilies," the artist began work on "The Gravity Observations," a series which occupied him periodically from the late 1970s through the early 1980s. Many of "The Gravity Observations" juxtapose the world of weightlifters—the milieu of Muscle Beach and Gold's Gym which Reiss encountered outside his Venice, California studio—with that of the art world. Again, the artist was "plateauing," presenting the levels of similarity and correspondence in variously coded arenas of human activity.

Reiss' large series, "The Dancing Lessons," was first exhibited at the Los Angeles County Museum of Art (LACMA) in 1977. The nearly thirty "Dancing Lessons" take dance as a metaphor for life, with each dance room embodying a different theme. "Sympathetic Forces" explores how parents try to recreate themselves by forcing children through dancing lessons, how children are civilized, socialized, conditioned by dance classes. One of Reiss' daughters is a professional dancer; the piece, of course, derives from his experiences of parenting.

But the artist's involvement with LACMA did not end with "The Dancing Lessons." In 1981, Reiss participated in the milestone exhibition "The Museum as Site." He created a group of figures called the "New World Stoneworks" which, if excavated five thousand years from now in the La Brea tar pits adjacent to the museum, would somewhat enigmatically reflect our culture. He produced a videotape of the pseudo-event of unearthing them, then situated the sculptures in plexiglass cases in various locations throughout LACMA to be "discovered" by museum-goers. Because the attached labels made serious mistakes of anthropological interpretation, viewers were alerted to how misleading attributions can be.

At the end of the 1970s, Reiss was working on the "Morality Plays" series, which assaults the issue of contemporary values, how they are manifest in the way we live. Each of the living rooms in the "Morality Plays" dissects a different family or relationship mode. Reiss presents the family that is constantly on the go, constantly traveling ("The Need for Certainty"); he explores the family that knows itself through common domestic activities such as ironing, vacuuming, etc.; he analyzes the couple that exists in a perpetual state of romance. Throughout the miniature rooms of the "Morality Plays," Reiss has strewn toppled columnar forms with the names of medieval or Victorian virtues and vices engraved upon their surfaces. In the "Morality Plays" we are forced to consider the meaning (or, more precisely, the lack of meaning) of these terms in contemporary society.

While he was working on the "Morality Plays," Reiss also began to build some life-sized installations. The title of the first, "The Castle of Perseverance"(1978), was taken from the medieval morality play of that name. "Castle" is a particle board codification of the suburban American living room. Although Reiss does not use miniaturization here, because he presents everything from the television to the sofa to the potted palm in the same material, viewers are forced to consider the form — and the meaning — of objects so familiar

they rarely demand our conscious consideration. As Lévi-Strauss suggested (see above), reduction in the number of properties serves the same function as reduction in scale. Reiss' 1980 "Security Specific" installation represents the inner and outer realities of corporate banking, encouraging viewers to move in and through spaces to which their access is usually restricted. The bank vault in "Security Specific" appears to have been frozen in the midst of a robbery. Reiss placed actual money in the open (and not yet dynamited) vault. While "Security Specific" was installed at Mount Saint Mary's College, $27.00 was removed from the artwork.

"Adult Fairy Tales I & II," the miniature series from the mid 1980s, explore the theater and hierarchies of the corporate world, proximics (the study of social space relations),[18] and the physical shapes our thoughts take in interior spaces. As with each of his series, Reiss here includes indexical signs to enhance the symbolic and dramatic readings. In each corporate tableau is an amorphous piece of art, which the artist refers to as the "generic corporate sculpture;" a laborer's tool like a welder or buzz saw, which can be read as a destructive threat as well as a class statement; and, in "Adult Fairy Tales II,"

a totemic wooden figure that alludes to the style of corporate logos but also functions to embody the primary emotive charge of the piece. In "Adult Fairy Tales II: Small Fires" (1984), a group of corporate executives stands inside a spacious office, calmly discussing business matters. Beside them, one of the older members of their group is repeated in silver. He stands on his head in the company of a burning briefcase and a flame-filled notebook. The silver figure represents the invisible emotional state of the executive. Regardless of being horribly upset, in total denial of approaching personal catastrophe, he dons a mask of equanimity in the business environment. Reiss' tableaus unmask the actors of the business stage, revealing their hidden personal realities, as did the news of the DeLorean scandal or the fiction of Tom Wolfe's novel *Bonfires of the Vanities* .

Between the "Adult Fairy Tales" and the current "F/X" miniature series, Reiss worked on two groups of small wood carvings and bronzes derived from various moody, art historical themes ("The Fates" from 1985 and "History Lessons" from 1986) and an ever-expanding repertory of single figures, which range from life-sized to gigantic. "Strange Cargo" is an exotic and romantic piece with echoes of Dante's apocalyptic vision and Gauguin's primitivism. A turquoise boat crosses a similarly hued River Styx. On board are a man, a griffin, a flaming torch, and a jagged mountain peak. "History Lessons: Revelations," with its cluster of awkward, tumbling angels, makes one wonder how, if they have such trouble flying, such celestial supernaturals could ever nurture and sustain the universe.

The large figures began with "Metroman," the angular plaster form cast from disparate architectural fragments, and evolved into "The Ball Game" (later simply "Players") composed of plastic, cement and paper pulp. In 1984, Reiss and his current wife, artist Dawn Arrowsmith, moved to a studio in downtown Los Angeles. The "Metroman" group, with its allusions to skyscrapers, construction, demolition, comes directly from Reiss' experience of living in the urban center and from his questions about how we become part of our environment/our environment becomes part of us.

The "Players"—such as "Mean Man," whose name and form contrast the Aristotelian concept of the mean (as the avoidance of excess) with the contemporary significance of "small" or "nasty"— are, like the monochromatic personae in the "Adult Fairy Tales II," distillations of contemporary character types.

In spring 1990, Reiss created the installation "Heat" for the gallery at Pasadena City College. Each of the 7' x 7' x 2' platforms from "Heat" physicalizes the dictum "You are the center of the problem." Viewers stand under the platforms, stick their heads through central holes, and emerge with their eyes at horizon level, surrounded by images of environmental devastation (an oil spill, a decimated forest, etc.).

All of Reiss' work, in effect, puts us in the center of the issues addressed. Whether miniaturized or reduced through material transformation, Reiss' work allows us to become the subject and thereby affords what Lévi-Strauss terms an aesthetic sense of pleasure. As we project ourselves into Reiss' tableaus or walk through his installations, we become twentieth century Gullivers, enveloped by the myths of contemporary existence—and forced to consider both the multiple levels of meaning in those myths and our own role in creating them.

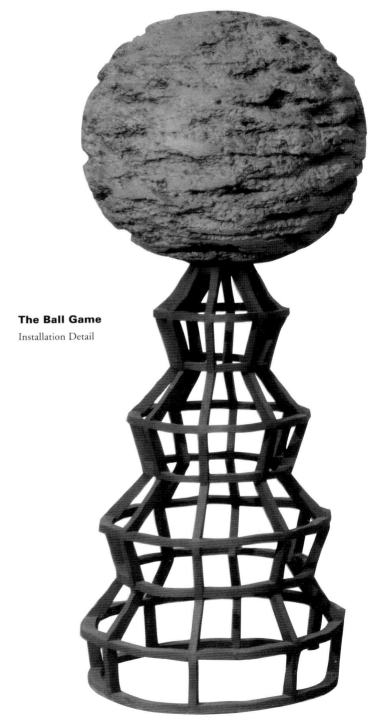

The Ball Game
Installation Detail

Footnotes

1 Umberto Eco, *A Theory of Semiotics.* Bloomington: Indiana University Press, 1976, page 244.

2 The biographical information in this essay is by no means intended to give a psychoanalytical reading, to offer a "psychobiography" in the manner of, say , Mary Mathews Gedo's "An Autobiography in the Shape of Alabama: The Art of Roger Brown," (*Art Criticism,* Vol. 4, no. 3, 1988). I do agree with Gedo, however, that an artist's major stylistic changes often have "intensely personal roots" and certainly find this to be true in Reiss' case.

3 I am reminded of Lazlo Moholy-Nagy's comments on "the choice of a calling" and how it is determined by such factors as "market demand." See Lazlo Moholy-Nagy, "The New Vision," reproduced in *Twentieth Century Art Theory: Urbanism, Politics, and Mass Culture,* Richard Hertz and Norman M. Klein, eds. (Englewood Cliffs, New Jersey: Prentice Hall, 1990).

4 All quotations are from interviews with the author in February and March of 1990.

5 Henry Schaefer-Simmern, "Preface," Conrad Fiedler, *On Judging Works of Visual Art* ([Henry Schaefer-Simmern and Fulmer Mood, trans.] Berkeley and Los Angeles: University of California Press, 1957), page vi.

6 T.J. Clark, "Clement Greenberg's Theory of Art." *Critical Inquiry* 9, September 1982.

7 Fiedler, *op. cit.,* page xvi.

8 Even to use film as a source opposed the dictates of modernism, at least those of its primary critic Greenberg, who explicitly cautions against anything that would hint at the merging of art and entertainment. See his "Modernist Painting," *Art and Literature 4,* Spring 1963.

9 Eco, *op. cit.,* page 66.

10 The primacy of language, first asserted by Lévi-Strauss and later endorsed by Lacan, "has come under attack by deconstructive philosophers such as Jacques Derrida. What has become clear is that perceptions of reality are dependent upon and constructed through systems of communication of which the arts are primary exemplars." Howard Risatti, *Postmodern Perspectives: Issues in Contemporary Art,* Englewood Cliffs, New Jersey: Prentice Hall, 1990, pages 120–121.

11 For a more comprehensive discussion of how Reiss' work relates to semiotics, see Richard Smith's essay in this volume.

12 Terence Hawkes, *Structuralism and Semiotics,* Berkeley and Los Angeles: University of California Press, 1977, page 17.

13 Claude Lévi-Strauss, *The Savage Mind.* Chicago: The University of Chicago Press, 1966, pages 23–24.

14 Jurgen Habermas, "Modernity vs Postmodernity," *New German Critique* 22, Winter 1981.

15 Rosalind Krauss, "Poststructuralism and the 'Paraliterary'," *October* 13, Summer 1980, p. 39. Quoted in Risatti, *op. cit.,* page 121.

16 Lisa Tickner, "Sexuality and/in Representation: Five British Artists," *Difference: On Representation and Sexuality* (catalog). The New Museum of Contemporary Art, New York, NY, 1984, reprinted in Risatti, pp. 228–229.

17 Tickner, *op. cit.,* page 230.

18 Eco, *op. cit.,* page 10.

Betty Ann Brown is an art historian and critic living in Pasadena, CA. Brown is an Associate Professor in the Department of Art: General Studies, California State University, Northridge. Her recent book, *Exposures, Women and Their Art* (NewSage Press), was co-authored with Arlene Raven.

Roland Reiss: An Artist for His Time

BY MERLE SCHIPPER

By 1977, the year that Roland Reiss' exhibition of doll house-sized tableaus, "The Dancing Lessons," breathed new life into a faltering Los Angeles art scene, Conceptual Art, and with it, the return of content, was on the rise. Reiss' tableaus were spurred by the advent of Conceptualism, a movement which had already found formidable attention in Europe and New York. In Los Angeles, the audience for Conceptualism was woefully small, despite at least two artists who preceded Reiss in allying with that mode: John Baldessari, who took his camera out of the studio to snap information, and Allan Ruppersberg who drew on fact and fiction to fuse art and life.

For Reiss, the tableau permitted a wider scope of content than traditional modes could offer. "The Dancing Lessons," broadly embracing the upper-middle-class values with which many viewers would identify and articulating elements of life-style with unrivaled fluency, were psycho-social dramas laced with wit. As narrative, a mode that was literally manifest in Ruppersberg's (and a little later, Alexis Smith's) use of books, they demanded to be explored over time.

Despite its lack of recognition, Conceptualism had been inchoate in the movement known as "L.A. Pop," in the early 1960s, chiefly through Edward Ruscha's word-as-image paintings, works which also shared attributes of Southern California's light-and-space tradition.[1] Reiss participated in the latter through investigations with molded plexiglass, as did his former UCLA classmate Craig Kauffman. Reiss did so while teaching in Boulder, Colorado; Kauffman remained in Los Angeles.

Those pursuits continued to be reflected in the light-immersed environments that radiated from Reiss' small-scale, table-mounted tableaus. They also emerged and glimmered in details like the molded plexiglass figure in "The Truth Table" (1974), the single element that departs from the tableau's all over plywood mono-chrome. "Adventures in the Painted Desert: A Murder Mystery" (1975) features painted clouds on its plexiglass walls.

Plexiglass had served to enclose Robert Graham's tiny female nudes executed in wax in the mid 1960s. Reiss had modeled small figures in wax, but absented human presence with the onset of the tableaus — "The Truth Table" and "Easy Turns, Happy Trails" excepted — until they returned in the highly imaginative "New World Stoneworks" (1981).

Other Southern California artists worked in miniature scale, among them Gordon Wagner, whose surreal spaces reminiscent of Joseph Cornell's assemblage boxes appeared in the 1960s and elicited attention from Reiss. Two others, Bruce Houston and Gifford Meyers, began to execute work in tableau form about the same time as Reiss.

The concept of the life-sized tableau had arisen in Los Angeles at the hands of Edward Kienholz, whose "Roxie's, A Bordello" appeared in the same year (1961) as East Coast artist George Segal's "Man Sitting at a Table." Segal's work was the first of his series of plaster figures in environments which often appear to have been cut out of the urban landscape. Life-size nudes emerged in John de Andrea's tableaus in 1962, followed by Duane Hanson's clothed, fool-the-eye replications of middle class Americans later in the decade.

Reiss, however, remained principally occupied with Lilliputian dimension over the decade 1975 to 1985. Those perceptive tableaus invited the viewer to *mentally* replace the figure in the narrative, but "The Castle of Perseverance" (1978) and "Security Specific" (1980), both temporary installations, were executed at human scale.

In those cases, the spectator physically entered, indeed, performed, as if engaging in the performance art that was implicit in "The Dancing Lessons" spaces which combined features of both dance and art studios. In the large installations, that participation effected a merging of art and life.

That phenomenon, originally implied by Robert Rauschenberg when he hung his "Bed" (1955) on the gallery wall, preoccupied pioneer conceptual artists. The seminal figure among them was the German Joseph Beuys, for whom form was only a vehicle for content. Reiss was well aware of Beuys but the work of Chicago-based H. C. Westermann and San Franciscan William T. Wiley, whose achievements articulated their social consciousness, was also influential.

Westermann's finely crafted, small-scale, mixed media objects fusing the genres of assemblage and tableau, first appeared in the mid 1950s and thus might be viewed as proto-conceptualist. Even by 1968, with the appearance of Westermann's "The Last Ray of Hope," a glass-enclosed pair of boots atop a pyramidal base to which the words of the title were attached, the designation "Conceptual Art" and its attendant vocabulary (much of it drawing on post-structuralist French philosophy and linguistics) were not yet audible in artist/critic circles.

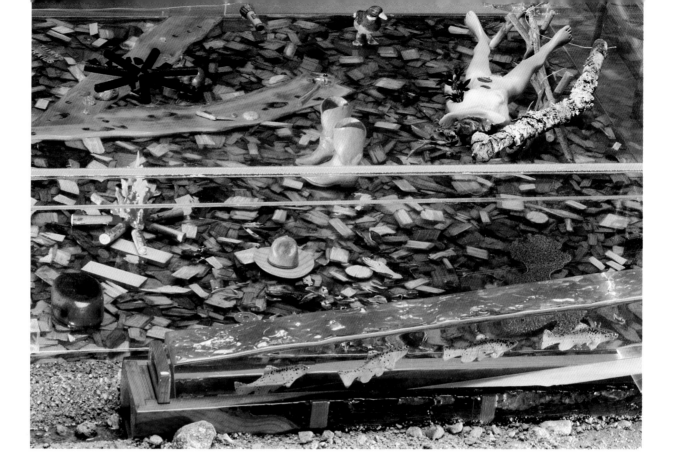

Easy Turns, Happy Trails: A Murder Mystery Detail

"Easy Turns, Happy Trails: A Murder Mystery

(1975) was sparked by an actual murder…"

This is conspicuous by hindsight in Max Kozloff's comments on Westermann's use of "a common sign language," declaring that "for aesthetic purposes, this language, its origin and rationale, is the key to understanding a remarkable group of sculptures."[2] Was Kozloff groping for the term "semiotics," which was not yet sounding from the lips of the art cognoscenti?

Semiotics became meaningful for Reiss by the time of the first tableaus. "Easy Turns, Happy Trails: A Murder Mystery" (1975) was sparked by an actual murder which had occurred at the University of Colorado some years before.[3] Drawings prompted by newspaper accounts led to the mini-replication of objects, many of them—fences, boots, cowboy hats—broadly alluding to ranch life, but also serving as clues leading to the arrest of the murderer.

Reiss already shared the penchant for metaphor and ironic wit that marked work by Westermann and Wiley. The latter was a member of the San Francisco community of Funk artists which included, according to Reiss, "the only people dealing with content in a viable way."[4] Funk art's wit ran from the outrageous to the absurd, unlike the "wry cool humor" in Ruscha's work, which Reiss admired but did not attempt to emulate. That Funk subject

matter was clearly articulated provoked Reiss to question its occurrence in Northern but not Southern California (although there were exceptions, as the work of Los Angeles assemblagists George Herms and Wallace Berman demonstrates).[5]

The practice of tagging pieces with mottos and slogans to address social issues in the manner of Westermann and Wiley is echoed in titles like "The Measure of Moral Phenomena" from Reiss' later "Morality Plays" series (1980), each furnished in imitation marble to symbolize the class of society which finds comfort in conformity. Single words such as "absurdity" and "honor," imprinted on what Reiss refers to as "morality planks," are propped against walls in "Morality Plays" interiors. These planks remind the viewer of the Ruscha paintings which began to appear in 1961.

As Reiss himself has acknowledged, he "came into art at the tail end of Abstract Expressionism." The modernist aesthetic with which he was ingrained as a UCLA graduate student in the mid 1950s was still evident in earlier tableaus. "Easy Turns, Happy Trails" tends to diagonals; in "The Truth Table," the eye can discern an underlying grid. Cigarette packs, hamburgers, coffee mugs and other pop-derived elements drawn from Reiss' "supermarket of images" are spread over

"The Dancing Lessons: Moving Violations," but these are not strewn arbitrarily. Instead, they occur in the precisely ordered disposition that again reflects a formalist sensibility, but placement and scale are strategically employed for their part in the narrative. Inconsistencies in relative sizes are deliberate, to accord with their importance. "Keeping Time," in the same series, makes a departure, however, in the massive unmatched, unaligned and teetering columns representing different art-historical styles. Here, although differences in scale are not more exaggerated than in other examples of the series, they stand out. Bordering on the comedic, the columns suggest a menacing force, even as their wavering predicts their own downfall.

Such scale discrepancies forecast Reiss' work in enlarged scale, in which formal concerns are for the most part abandoned. In "The Fates: Present Tense" (1985), height is increased to thirty inches with figures looming over trees and an ominous rocket dwarfing a mountain. More recently, in "Players," a series whose name makes allusion both to performance art and to the drama that is real life, figures rise to a height of ten and eleven feet. "Players: Hero" (1989) dwarfs a normal sized chair.

Indeed, incongruities serve to intensify the drama of Reiss' "Heat" (1990), which is scaled overall to underscore the social content that binds the work to conceptualism. The manipulation of scale that is Reiss' singular forte serves his purposes never better than in this four-part installation suspended from the ceiling, which testifies to the capacity of "progress" to destroy. Between two table-top units—one suggesting an oil spill, the other a decimated forest—the contemporary metropolis dangles, flame-red in hue and dominated by the cluster of towers-of-power encircling the viewer who stands in a central opening. Here, concentric rings of buildings gradually diminish in height from innermost to outer edge, where small houses overlook the threatening void.

Footnotes

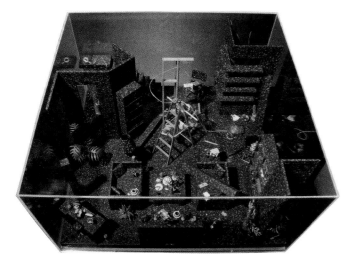

Players: Hero

Installation Detail

1 Anne Ayers, "Impure Pop: L.A. Painting in the 1960s," in *L.A. Pop in the Sixties* (catalog). Newport Harbor Art Museum, Newport Beach, CA, 1989, pages 13–25. Ayers cites Baldessari as contributor to "L.A. Pop."

2 Max Kozloff, *H.C. Westermann* (catalog). Los Angeles County Museum of Art, Los Angeles, CA, 1968, page 6.

3 Another artist dealing with "mysteries" for which the work provided clues was Barry Le Va, in work executed 1968 to 1972. See Robert Pincus-Witten, "Barry Le Va: The Invisibility of Content" in *The New Sculpture: 1965–75* (catalog). The Whitney Museum of American Art, New York, NY, 1990, page 321.

4 All quotes from the artist are from conversation with the author, April 1990. See also Peter Selz, *Funk Art* (exhibition catalog). Berkeley: University Art Museum, 1967. Funk was originally a jazz term. According to Selz, it was opposed to New York's "primary structures" and Southern California's "finish fetish" sculpture.

5 Reiss distinguishes his work from assemblage through his choice of new, rather than found objects, as primary resources. In making and selecting such objects, he is assured that the finished work will elude any aura of nostalgia that would be associated with assemblage.

**The Morality Plays:
The Measure of
Moral Phenomena**

Merle Schipper is an art historian and free-lance critic based in Santa Monica, CA.

Roland Reiss: Upscale and Down

BY BUZZ SPECTOR

The sculpture of Roland Reiss operates through exaggerations of scale, fluctuating between the miniature and the gigantic. Observing his Lilliputian rooms under plexiglass, crowded with tiny fabrications of otherwise mundane furniture and accessories, we are granted the transcendent visual sense of Gulliver. Similarly, in the midst of one of the artist's occasional exercises in installational gigantism, our perspective recalls the astonishment felt by Jonathan Swift's famous traveler at his discovery of Brobdingnag.

The scales that Reiss utilizes may vary over time, but the proportional relationships that animate individual works demonstrate that his primary concern is with the situation within the situation. It is this conceptual interiority that encourages our notation of the myriad details of his tableaus with the delight of readers uncovering the clues in a mystery novel. As early as 1975, Reiss made explicit references to this association in the titles of box works such as "Adventures in the Painted Desert: A Murder Mystery," in which a minuscule desert scene includes a postage stamp-sized monochrome painting (in the manner of Brice Marden) that has been pierced by a tiny arrow.

Earlier still, beginning in 1968, Reiss made thousands of small plastic casts of various objects, animals, and human figures, which he arranged in his studio as if in martial formations. It wasn't until 1974, when he began placing his miniatures into clear plastic boxes, that these castings became characters in absurd and poignant situations. Reiss has continued this production ever since, and several shelves in his studio are filled with arrays of tiny mechanical devices, foodstuffs, furnishings, and other cultural artifacts. These quotidian items are strewn about the spaces within his boxes, like props on so many stages.

Reiss' little rooms are similar in scale to doll houses, but without their nostalgic appeal. The doll house resists contemporaneity, being concerned with objectifying the longing for an idealized childhood. Its furnishings are often miniature replicas of antiques, signifying the past in the form of a dream of wealth and preindustrial craft. The play of the doll house is directed toward an order and control consistent with the interiority of such a reverie. In contrast, Reiss makes environments that are usually up-to-date and deliberately disordered. His diminutive living or dining rooms, health clubs, dance studios, and corporate offices are cluttered with the detritus of adult life— TV sets, exercise equipment, discarded

magazines, potted plants, cigarette-filled ashtrays—all set within generic interiors.

Although self-contained, the space of the doll house is at least partially open to the manipulations of the viewer, usually

The Ball Game

Installation Detail

Adventures in the Painted Desert: A Murder Mystery
Detail

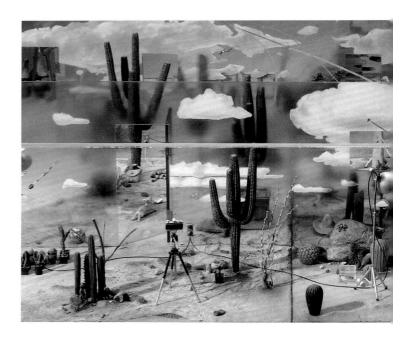

through the missing or detachable rear wall of the structure. This opening makes the multiple stories of the doll house into an array of chambers equally accessible from the outside but isolated from each other. There is only one story—often only one room—in each of Reiss' boxes, with the clear sides and tops usually standing in for walls and ceilings omitted from the architecture. While the plexiglass leaves more of the enclosed space visible, it also seals off the work from any possibility of alteration by the viewer. As such, it invites speculation rather than domestication.

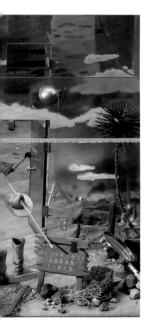

The ironies that inform Reiss' work aren't based on miniaturization alone. His lifesized installation in particle board, "The Castle of Perseverance: A Moral Model," first exhibited at Newport Harbor Art Museum in 1978, includes constructed bottles, glasses, cups, spoons, books, and other accessories, with the furniture covering its 29-foot square particle board floor. Even the piles of art magazines positioned on a coffee table are carefully proportioned slabs of unpainted board. The use of a single material throughout the installation, along with the uninflected surfaces of the larger pieces of furniture, gives the room the attributes of an outsized model rather than an environment in human scale. Reiss' manipulation of the particle board becomes a kind of overarticulation of details, pervading the space with an attitude of material and textural estrangement.

Reiss began working with multiple scales in 1985, while preparing an installation for Ace Gallery in Los Angeles. Entitled "Metroman," the installation included clusters of urban architectural structures in hydrocal and steel, measuring four feet or less in height, together with an array of life-size or larger figures, up to eight feet tall, each apparently straining against, within, or beneath quantities of building elements. Many of these figures, also made of hydrocal over steel, had various body parts replaced by architectural fragments

—prostheses from the histories of buildings and sculpture. The disparity of scale between figures and architecture made the group of struggling giants seem to tower over the buildings, while the efforts demonstrated by the figures, obviously engaged in labors of construction, were thus made to seem out of proportion to the size of the edifices near which they were displayed. Traversing the space, visitors found themselves in between tokens of the enormous and the tiny, and therefore distanced from both conditions. This dual estrangement made the "normal" scale of the viewer into simply another anomalous element in the situation.

Unlike Reiss' boxes, his larger scale work shares the space of the viewer. The plexiglass walls that demarcate our privileged view of the situations within the boxes also prevent us from intervening in those affairs. Looking up at Reiss' giants, we encounter no such protective barriers. But while the absence of boundaries allows us to freely circumnavigate these gargantuan tableaus, their sheer scale ensures that we won't alter them. In this way, Reiss permits his audience a reversal of its proportional relationship to the work without also changing the nature of its viewing relationship.

"Heat," a 1990 installation at Pasadena City College, encouraged viewers to examine its trio of tableaus, depicting ocean waves, clustered skyscrapers, and forest vegetation, from the inside. Each of the three platforms, suspended from the gallery ceiling, had a central aperture allowing the agile visitor to crawl beneath it, emerging into the midst of the setting. Through this access, the viewer also became an active element in the situation. Other viewers, witnessing this activity, assumed the role of Lilliputians observing Gulliver from a distance. This viewpoint represents distance appropriated for the power and allusiveness of art.

Reiss' work is a consummate reflection on the meaning of scale. In its displacement of conventional size, it offers us different vantage points from which to reconsider the proportions of our own lives.

Buzz Spector is an artist who lives and works in Los Angeles, CA.

How Does an Object Tell?

The Semiotic Dimension of Roland Reiss' Sculpture

BY RICHARD SMITH

In a college art gallery, four viewers look at a "Murder Mystery" by Roland Reiss; for nearly half an hour, they debate what happened to produce the scene inside the box. A French dance company, visiting the home of an art collector, gathers around one of Reiss' "Dancing Lessons." They all agree what happened inside the box—there has been a fight between the dancers and the choreographer—and they describe the fight in detail. Most of us respond to these works in a similar manner. We draw into groups, we point and discuss, and most of all, we tell stories. Why? Clearly, something has happened, or is happening, in most of these tableaus, for the scene is often in great disruption. Disturbance of a situation is the most primary of narrative devices,[1] but there are more complex and richer reasons that we tell, or rather that the pieces prompt us to tell, stories. Although Reiss' work has often been described as narrative, there has been little investigation of method, or even speculation about why narrative, in a period when structures and systems get all the attention, should even interest us.[2] Structures, however, the elaborately coded semiotic structures that Reiss creates, join and hinge the stories that we unfold.

A useful example from art history is the Enlightenment philosopher Denis Diderot, as he stands before and describes the paintings of Jean-Baptiste Greuze. In the Salons of 1761, 1763 and 1765, Diderot displays an unrestrained talent for spinning a story from a painted scene. From "L'Accordée de Village" to "Le Fils Puni," he uses many pages to describe the characters, their relationships, their motivations and even their activities prior to entering the tableau. He connects characters over the years from one painting to the next and praises Greuze's ability "to serialize events in such a way that one could write a novel about them."[3] According to Norman Bryson, what fuels Diderot's imagination is Greuze's exaggeration of the semiotic codes for family and morality.[4] "Differences carry signification," said Ferdinand de Saussure at the founding of semiotics,[5] and Greuze exploits those differences. There is not a parent without a child, not youth without age and not virtue without vice, all depicted in their extreme contrasts. Likewise, Reiss' "Adult Fairy Tales" examine the codes of behavior within the corporate environment and the differentials between employees, middle management and top management. In his critical writing on painting, on novels and on theater, Diderot developed his theory of the tableau; similarly, Reiss prefers the word "tableau" to describe his pieces, but

shifts its significance to embrace its root meaning, table (the pedestal upon which he builds up his miniature universes), as well as tabula rasa (the blank mind upon which society constructs its patterns). To compare Reiss with Greuze, through Diderot's eyes with Bryson whispering in one ear and Saussure in the other, is only partially instructive, for there are serious limitations. Reiss creates "open" narratives, to use Umberto Eco's term,[6] with neither the plot nor the message entirely clear, while Greuze is always preaching. Also, Bryson does not attempt to explain why such forcing of the differential values of a semiotic code should generate sequence, should tell a story. Nor does this approach answer a fascinating problem Reiss' work raises: in the most narrative of the series, the "Dancing Lessons" and "Morality Plays," human beings are absent from the scene. We will return to the problem of narrative at the end of this essay, but first we need to look at Reiss' use of semiotics and cultural codes.

"Narrative," Reiss told Merle Schipper in 1979, "is the term that is the tip of the iceberg…which is called content."[7] When, a decade earlier, Reiss rejected the formalist, progressivist, reductionist line of modernism, he began to overload his work with information and objects. "I dumped less is more for more is more," he says.[8] The content that began to flow into his pieces, however, was complicated by multiple interpretations and unending ambiguities. Many forces contributed to this complexity, but Reiss focuses on one anecdote. In 1968, a music student was brutally murdered in the auditorium at the University of Colorado, where Reiss was teaching. Every evening he made a drawing of the murder scene, as described in the newspapers. Over the days, Reiss noticed that the descriptions and the drawings changed. Eventually, he was able to realize, on the same day that the police made an arrest, that a custodian had committed the murder. Thus began a fascination with the synchronic layering of time and the slippage of information. Alain Robbe-Grillet's novel *The Voyeur* offered Reiss a parallel, where one event, a murder, is viewed again and again with increasing ambiguity. This fascination came to realization in 1975 with "Easy Turns, Happy Trails, A Murder Mystery."

The crime is separated into two planes: as it occurs and above, the police reconstruction. The two do not match up; objects that appear in one plane are missing in the other. Further, our observation of the scene is filtered through four "information planes," texts screened onto clear plexiglass. This information—a horoscope for the victim, the events leading up to the murder told in detective book style, a map of the area and a weather diagram—do not lead to any clear conclusion, although there is a general metaphor at work: the muse has been murdered by an artist. From this piece onward, Reiss continues to play with binary and quaternary oppositions, chronological, spatial, metaphorical, that are split or superimposed in multiple synchronic contradictions.

Adult Fairy Tales II: Personal Focus
Detail

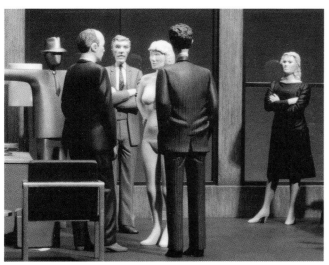

As he developed a personal vocabulary to think about his method, Reiss used the word "plateauing." Dissatisfied with the term "symbol" to describe the multitude of objects that began to crowd his work, Reiss began to use the term "clue," then later shifted to "cue." He was feeling his own way toward semiotic language when, in 1976, he read Eco's just-translated *A Theory of Semiotics.*

Eco's theory is very compatible with an artist's concerns, for it is developed more out of the logical tradition of Charles Pierce than the linguistic tradition of Ferdinand de Saussure. Eco's examples are predominantly visual. The Saussurian tradition had to be transferred over to non-verbal languages, first by French anthropologist Claude Lévi-Strauss to kinship systems and then by critic Roland Barthes to fashion and other languages of popular culture. Concepts from both traditions help us interpret Reiss' sculpture. Eco, following Pierce, defines a sign as "everything that, on the grounds of a previously established social convention, can be taken as something standing for something else."[9] This is not as clear as it sounds, for the "something else," in the Pierce tradition, is just another sign. We constantly try to clarify meaning but all we are really doing is replacing one sign with another, such as a picture, an association, or a translation. It is like looking up a word in the dictionary,

where all you get is more words leading to still more words. Eco calls this "unlimited semiosis." Pierce tried to classify these different kinds of signs, but the kind that has interested Reiss the most is the "index." An index indicates, as a footprint indicates the passage of a person, but also as a running shoe in the "Morality Plays" indicates leisure, a suitcase indicates mobility and a safe indicates both wealth and the need for security.

Semiotics, the study of signs, is primarily the study of coded signs. It has come to concentrate on the way people (actually cultures) use signs in tight patterns along two axes, the syntagmatic and the paradigmatic. Syntagm, because it takes context to give a sign any meaning. It takes a word to give /p/ meaning, it takes a sentence to give /piece/ meaning and so on (slashes, following Eco, indicate a signifier). Likewise, to use an example from two pieces by Reiss, an axe means something different in the woods than it does in a corporate office. Paradigm, on the other hand, implies that any sign is given its value primarily by the choice of substitutions which could have been made in that context, but are absent. When writing about Reiss, I can choose from among the paradigmatic class /piece/sculpture/work/object/tableau/miniature/ and so on. This paradigm can be seen as the vertical axis and the syntagm as the horizontal.

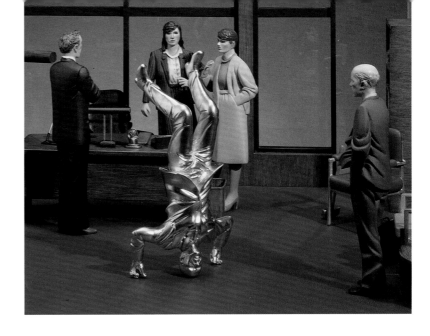

Adult Fairy Tales II:
Small Fires
Detail

Paradigmatic choices are not innocent; they position one's alliances and oppositions. If, for example, I describe his /figurines/, neither he nor I will be taken seriously. Consider the contentiousness of the following paradigmatic options from recent events in the Mideast, /hostage/ guest/detainee/prisoner/human target/. The elements of the paradigm can be anything that a society attaches with coded value; wearing a particular color and crossing an invisible boundary can get a person shot in Los Angeles, "To wear a beret or a bowler hat does not have the same meaning," Barthes wrote.[10] The meanings that we think signs have are neither inherent nor natural, we assign meaning to what is simply contrast. For Saussure, a sign is not only "different," it is "arbitrary."

The working method Reiss developed reveals this relation between syntagm and paradigm. Initially, he makes dozens, or hundreds of objects: pianos, chairs, light fixtures, food, shoes, sporting equipment, which he calls "runs." Each run is clearly a paradigmatic class, like the string of words under one thesaurus entry, which can substitute for one another in the same position. In combination with other objects they form the syntagm, or sentence, or in this case the tableau within the box.

Thus each object is given value not only by its alternate substitutions, which are absent, but also by the surrounding objects which are its context. A chair, to use one of Reiss' common objects as an example, denotes a seat with four legs and a back. Its connotative value, however, its associations, vary as Reiss exchanges /metal folding/straight-backed wooden/ bentwood/swivel/ chair, then further arranges it in groupings with other objects in different settings. A syntagmatic shift can change the value of the object (the sign), as well as its surroundings. The axe lying in the corporate office in "Adult Fairy Tales" startles us with its incongruity. Reiss has included such a "noble work tool," an axe, a hammer, a saw, a pike, in each piece of the series. In an environment where millions of dollars change hands on computer screens, the semiotic function of the noble tool is dramatic. Since to signify is to differ and a sign is, according to Saussure, "what the others are not,"[11] then the noble tool makes several suggestions about class differences and physical labor versus corporate office work. Other, more marginal differentiations permeate the environment, such as the cultural codes of short/long skirts, or light/dark suits. Reiss also uses this series to pursue his interest in proximics, the cultural use of space and gesture to produce signification.[12] The size and placement of the furnishings, the distance

"Narrative," Reiss told Merle Schipper in 1979, "is the term that is the tip of the iceberg…which is called content."

between the people, their relative positions of sitting/standing, facing/not facing and their gestures, hands in pockets/on hips/behind back/pointing/arms folded, all code the hierarchy of power within the corporate office. By painting all the objects the same color, Reiss reveals that nothing is outside the code, all signs are interrelated and determined by a larger cultural discourse.

The noble work tool questioning its corporate environment grows out of the ethic of Reiss' own labor-intensive approach to making art, but it reveals a larger theme that permeates his career; the socializing forces that constrain us are somehow unnatural. Even as he questions the concept of "natural" (photofloods everywhere), we are all being trained, like the trees in "Teaching Your Partner to Dance," with pruning shears and chain saws. In "Adult Fairy Tales II," the pressure of the situation forces the psyche of the focal character, as a ghost-white figure, to stand on his head or kneel abjectly. This impact of the culture upon the individual has led Reiss to describe his work as "Psycho-Social Environments."[13] The "Adult Fairy Tales" constitute a penetrating visual exposition of the structures of power in our society. Such pieces as "Conventional Wisdom," "The Politics of Persuasion" and "Secret Doctrine" manifest French

philosopher Michel Foucault's argument that power is not "something that one possesses, it is exercised in a relation of force."[14]

How do these objects tell stories? Traditionally, since Plato and Aristotle, there has been an opposition between showing (mimesis) and narrating (diegesis). Thus the visual arts, considered mimetic, were contrasted with the time arts. This neat division has been confounded several times, most strongly in contemporary film criticism.[15] Also useful is Lévi-Strauss' analysis of myths not according to their plot lines but to their "constituent units," which, on the model of Saussure, were "pairs of oppositions."[16] Clearly, if a story can be described as a structure, then a structure can be described as a story and this has been accomplished by French theorist A. J. Greimas. Greimas also works with binary oppositions, but moves from a static to a dynamic pattern. A sign generates not only its contrary, but also its contradiction and its complement. Thus virtue generates vice, nonvirtue, and nonvice. A diagram of this is Greimas' famous "semiotic square."

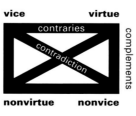

Describing the transformation of the terms is the articulation of a narrative pattern. He was a good man, but he fell in with friends who were not good; when being bad got him into trouble, he decided not to be bad any longer. Such forces push the narratives in Reiss' work and several semiotic configurations, layered over each other, enrich the narrative. In the diagram above, I chose "virtue" because of the engraved columns that lie about in the "Morality Plays" like motivational vectors. The engraved words are drawn from the classical vices (avarice) and virtues (diligence), antiquated Victorian sins and graces (maliciousness, modesty) and contemporary terms (disappointment, compromise). Additionally, a series of contemporary foibles are visually signified (beer cans and cigarette butts; self-indulgence). The scene of our contemporary morality play is, appropriately, the living room, our "Castle of Perseverance." Greimas' lengthy study "On Anger," one of the classical vices, is pertinent. With such a passion, he argues, "we are dealing with a discursive sequence, a syntagmatic configuration."[17] Anger logically presupposes a prior state, it is a feeling of "displeasure" according to my Webster's Ninth New Collegiate Dictionary, which is its complement on the semiotic square.

All states, being semiotically complex, are unstable and subject to disruption, thus the conflicts around the square tell a story. Such contrary relationships characterize most of Reiss' sculptures, for example suspicion/trust in "Security Specific." Frequently, several articulations are at work, as in "Moving Violations" from "The Dancing Lessons:" invited/stood up, honor/humiliation, male/female. Such layering dramatizes the manner in which the social codes position our roles as individuals and, furthermore, explains why, even with the absence of characters in many pieces, stories unfold. "I wanted to set all these forces in motion,"says Reiss, "but I didn't want to be the author of a text." Thus the elaborately coded environment of a Reiss tableau and the language of objects that fills it initiate an articulated, sequential response. In our description of this response, in its very syntax, is a story. The viewer, then, in the imagination, becomes both the teller and the actor.

Footnotes

1 Tzevetan Todorov, *Introduction to Poetics*, trans. Richard Howard. Minneapolis: University of Minnesota Press, 1981, p.51.

2 *Return of the Narrative* (catalog). Palm Springs Desert Museum, Palm Springs, CA, 1984. Kim Levin, "Narrative Landscape on the Continental Shelf," in *Beyond Modernism*. New York: Harper & Row, 1988, pp.89–98.

3 Denis Diderot, *Salons*, ed. Jean Seznec and Jean Adhémar (vol. 1 and 2, 2nd ed.) Oxford: Clarendon Press, 1975.

4 Norman Bryson, *Word and Image*. Cambridge: Cambridge University Press, 1981, chaps. 5 and 7.

5 Ferdinand de Saussure, *Course in General Linguistics*, (trans. Wade Baskin). New York: McGraw-Hill, 1966, p.118. (First published in 1915).

6 Umberto Eco, *The Role of the Reader*. Bloomington: Indiana University Press, 1976 and *The Open Work*, (trans. Anna Cancogni). Cambridge: Harvard University Press, 1989.

7 "Roland Reiss in Conversation with Merle Schipper," *Visual Dialogue* vol. 4 no. 3, 1979, p.4.

8 Quotations and much information in this essay are from an extended interview with Roland Reiss conducted in May, 1990.

9 Umberto Eco, *A Theory of Semiotics*. Bloomington: Indiana University Press, 1976, p.16.

10 Roland Barthes, *Elements of Semiology* (trans. Annette Lavers and Colin Smith). New York: Hill and Wang, 1968. p.27; also chap. 3, "Syntagm and System."

11 Saussure, *op. cit*, p.117.

12 Edward T. Hall, *The Hidden Dimension*. New York: Doubleday, 1966.

13 *Psycho-Social Environments* (catalog). Santa Barbara Museum of Art, Santa Barbara, CA, 1981.

14 Michel Foucault, *Power/Knowledge* (ed. and trans. Colin Gordon) New York: Pantheon Books, 1980, p.89.

15 Christian Metz, *Film Language: A Semiotics of the Cinema*, (trans, Michael Taylor). Chicago: University of Chicago Press, 1991, pp.96–99, 143–44. Etienne Souriau, "Time in the Plastic Arts," *Journal of Aesthetics and Art Criticism* (1949), pp.294–307.

16 Claude Lévi-Strauss, *Structural Anthropology* (trans. Claire Jacobson and Brooke Grundfest Schoepf). New York: Basic Books, 1963, chap.11, "The Structural Study of Myth."

17 Algirdas Julien Greimas, *On Meaning: Selected Writings in Semiotic Theory* (trans. Paul J. Perron and Frank H. Collins) Minneapolis: University of Minnesota Press, 1987, especially chaps. 3, 4, and 9. For further definitions of the "semiotic square" and other terms used in the present essay, see Gerald Prince, *A Dictionary of Narratology.* Lincoln: University of Nebraska Press, 1987.

Richard Smith writes art criticism and teaches in the Religion Department at the Claremont Graduate School.

Roland Reiss' Special Effects

BY ROBERT DAWIDOFF

Reiss explores how we see by making

things the eye can't resist looking at.

Sometimes it seems that postmodern consciousness is a small arena of special effects, mechanical explanations of why what we see we see the way we do. The Greeks had gods and the Judeo-Christian-Moslems had God; we have images, sets, effects, lighting, sound, scripts. One's world becomes an expanding set of miniature examples and instances. They offer us an understanding of sorts, an immediate explanation of the appearances that pass for circumstances. They are not, after all, devoid of mystery, beauty, interest, and sciences, but theirs is a found world, a put-together mystery, a technologically remastered dream.

What does Kansas look like after you find out the truth about the Wizard of Oz? Maybe it looks like home sweet home, or maybe it looks like Roland Reiss' most recent work.

The best thing about this work is that once you've started seeing it, you lose the distinction between what you see in it and what it makes you see. It is blissfully familiar and also unexpected. It comments on our cultural experiences by paradoxically recreating new creations. Reiss explores how we see by making things the eye can't resist looking at.

Roland Reiss has always made art that prompted thinking, while it reflected thought. This recent "F/X" series, however, lays claim to the things we have got in the habit of remaking and putting them together—or is it back together? He offers us a crystal ball look at the scenes of our imaginations, the ingredi-

ents of our myths. He brings the freeze frame of the passing culture to life and it turns out to be a curious, beguiling and stimulating place to inspect and from which to project.

Everything in "F/X" is the same and everything is different, everything is what it seems and, of course, nothing is what it seems. The easy promise of the box sets is understanding. See how these images are made, see the scene of action and interaction. Reiss dares to make his canvas the sound stage and his frame the studio which houses it.

Surely something so knowing results in a controlled knowledge. But his eye for detail, his artistry and his awareness of how little mere awareness can yield, focus Reiss' eye clearly on what we in this media age think we know, but maybe don't. His images show what amazing simulations of what preposterous realities we have become accustomed to. Monsters, exotics, lights, camera actions, colors—what colors!—angles and points of view beyond what Adam could have had, even as he named everything for the first time in the garden. Reiss discovers with wit and ingenuity the angles technology enshrines and the ones that escape its radar webs. Reiss rediscovers what Icarus, Leonardo or Edison knew about technology: its projections represent human

ingenuity in creating a space we seem to master in a world that bewilders us. There is beauty and wit to such space. It amounts to the scenes of life, but it remains constructed, imitated, approximated—the models, images, hopes, slices, renditions of the world, but not the world, cosmic projections but not the Cosmos. Reiss knows that human beings make themselves the center of a world that gives incomplete evidence of being made with human capabilities chiefly in mind.

"F/X" makes art of this imaginative space.

The elements of these cosmic projections, these stages on which we long to strut and fret, look every which way: back to nature, ahead to edited file tape, whatever. Unlike Reiss' mystery and morality stories, "F/X" releases the narrative hold, licensing the diverse narrative flows and raising the question of narrative itself.

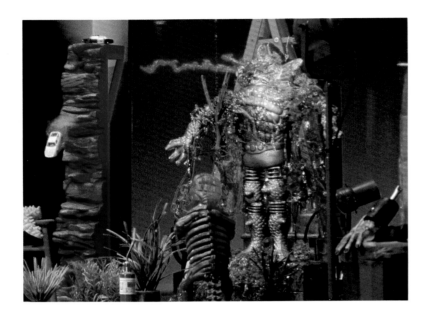

F/X: Ritual and Romance
Detail

We have learned from/with Reiss what Betty Ann Brown calls "the myths of contemporary existence" and are "forced to consider both the multiple levels of meaning in those myths and our own role in creating them." "F/X" takes us further, I think, to consider how constructed, how far flung, how found our world is. The individual figures suggest how people must remake for their own uses things that were not meant for them. Reiss' work suggests that we order the world from what we find in it and what we want of it. Reiss is no pop fetishist. His refreshing lack of sentimentality is a notable feature of his work with popular culture and its objects of art.

The figures compose into realistic narrative lines and fantastic ones. So long as you keep the camera's distance, you can make out the levels of the story. You may, if you prefer, take Reiss up on his behind-the-scenes setting, his seductive knowingness. "F/X" implicates the knowingness of our particular cultural climate. Peopling its setting with the available images of our confusion, it specially fuses the savage/ancient/primal/natural to the too conscious/postmodern/mock primal/artificial. Is this the tropics, is it the mall?

Is life made from such sets? Which is apparent, which real? Is this life or the truly universal studio tour? Once on the set, just where are you? Your guess is as good as mine—and not as good as Roland Reiss'.

Reiss indulges our conceits about how aware we are, how hip, to reintroduce us to secrets, fears, fantasies, to the childish permanences of our impulses and images and to our highly developed, but perhaps not really matured, techniques. Like much of what delights us, "F/X" recognizes what sophisticated children we are, how prey to our fears, how beholden to the imagination, how technologically apt and how little wise, how much we like to find things out and how little to remember. It is like his other work in its deceptively considerable skill and ingenuity, in the good cheer and generosity of its depictions and in the searching light of its look at things. Reiss is a master of the art of postmodern knowing, a knowing master of postmodern art.

Robert Dawidoff chairs the Graduate Faculty of History at the Claremont Graduate School. His latest book, *The Gentile Tradition and the Sacred Rage: High Culture and Democracy,* **will be published by the University of North Carolina Press in 1992.**

"Easy Turns, Happy Trails" is set in the Pacific Northwest. It is fictional, but it grew out of my study of a real murder. It includes several levels of time, as when the police recreate a crime. The changes in time are signaled by objects being translucent or transparent. On the far right is a translucent trout farm, where fish are domesticated and caught. I mean to indicate by the farm that this is a civilized, intellectual forest. There's a forked cedar path carved in the ground, indicating that you have choices to make in finding your way about.

At the rear are several information planes. One is written in detective magazine style. Another is a horoscope of the victim, who symbolizes the modern muse, the inspiration for contemporary art. Other planes trace her movements, how she enters the forest, what she encounters, whom she meets, etc. All of these characters and activities are comments on different attitudes about artmaking. So the piece is also an investigation of artists' belief systems and the possible consequences of holding such views.

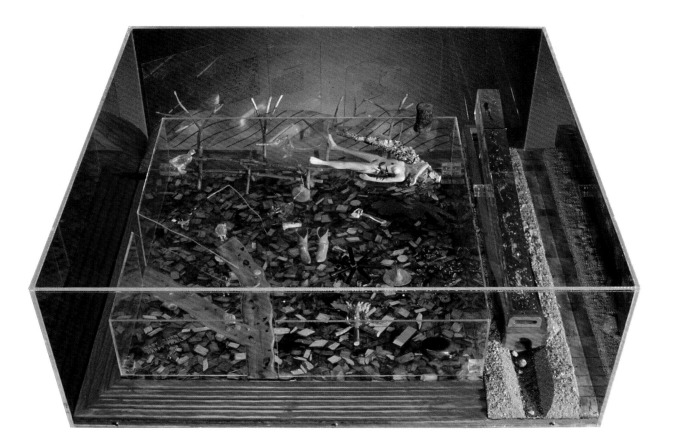

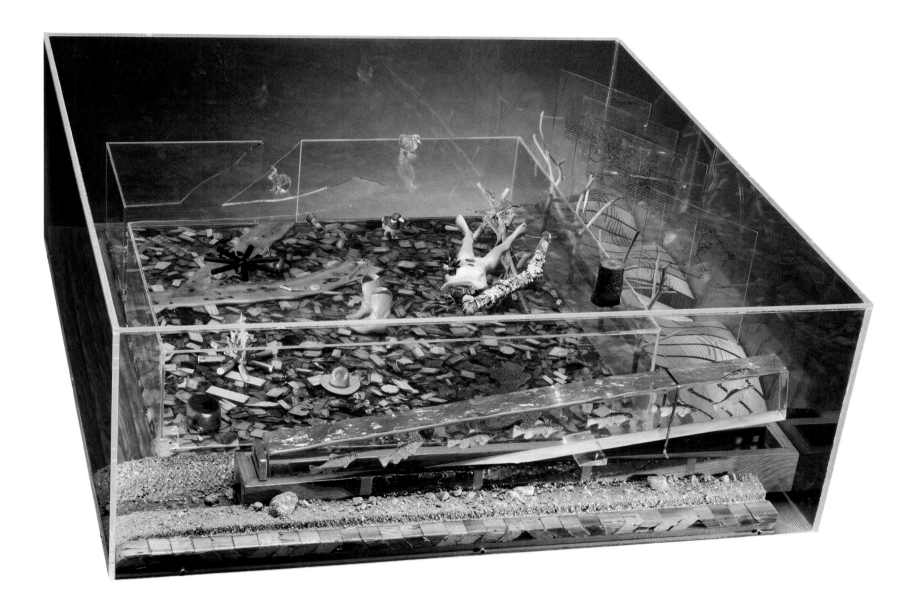

Easy Turns, Happy Trails: A Murder Mystery

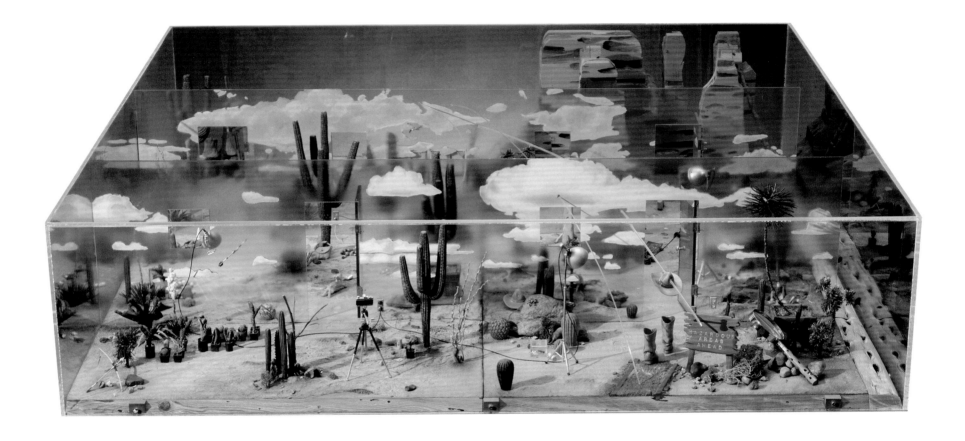

Adventures in the Painted Desert: A Murder Mystery

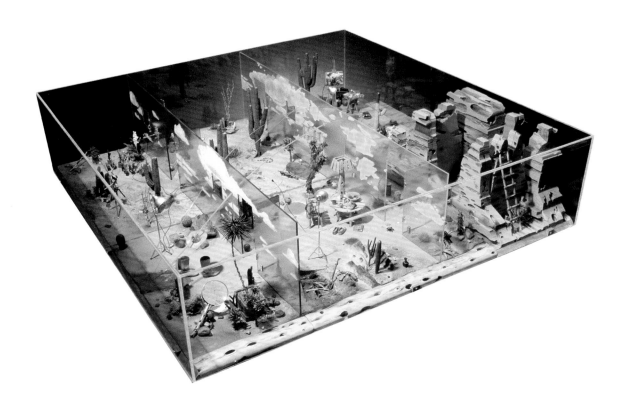

The key to this tableau, which was conceived in the context of what the critics called the "death of painting," is found in the small letter at the front, under a microscope. It's one of the kinds of letters I've received from students, from someone who's not been painting but is going to begin painting again. The letter is full of cliches, like "I'm going to show it like it is" and "A picture is worth a thousand words" (which I still believe, by the way.) So, in effect, the piece is my answer to this person. I want to say something about what it means to be a painter. That's one level; the art world. But the other level is more general.

I'd come to the realization that while the art world was an exclusive kind of club, the things that happen in it are the same things that happen in the real world. The art world is a microcosm of the real world. So in a larger sense, the piece is about being a creative person today, about the dangers and rewards of that kind of activity. The desert is the setting in which this drama is played out.

There is a two-panel painting in the sky, a Brice Marden monochrome. It represents the kind of reductionist painting that I'd left behind. I thought of the desert as a perfect metaphor for that kind of aridity.

There's an Apache arrow shot through the Brice Marden painting; I saw the arrow as standing for new attitudes and new ideas. Ultimately, the arrow represents the postmodern attack on prevailing art and its canons.

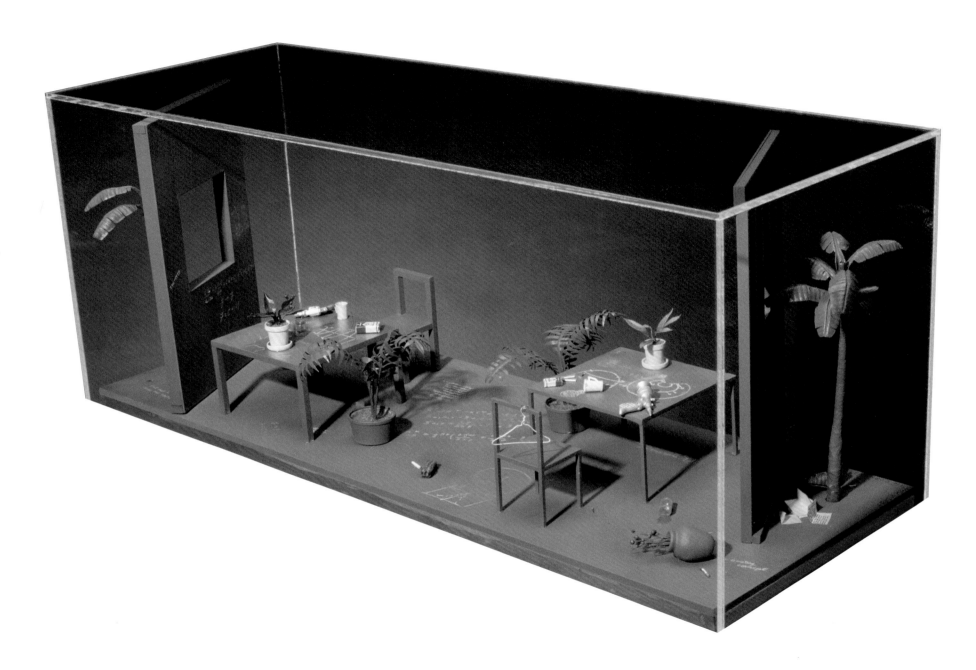

The Gravity Observations: I Keep Wondering

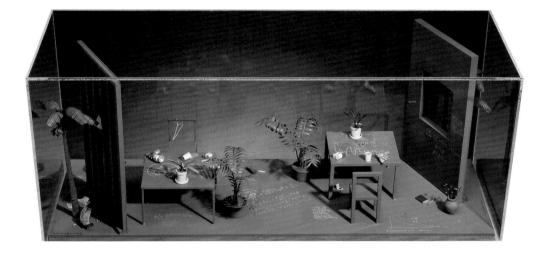
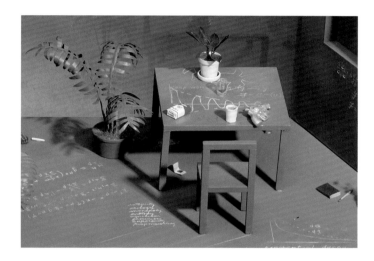

This has a small letter behind one of the walls which says, "Basically I'm an optimist, but the way things are going lately, I keep wondering." The piece is an effort to project what art will be like in the future, and it's a comparative situation. The "Table of the Present" and the "Table of the Future" are juxtaposed. The "Table of the Present" is full of signifiers about contemporary existence. A gun signifies the violence in current experience. The "Table of the Future" is "downsized," which means it's the same height and width but it's thinner, made of less material. There's a ray gun on the "Table of the Future" to suggest that violence will continue to be a problem as time goes on.

The piece is like a mathematician's green board dream. It's painted in green board slating and I have mathematical formulas written all over it. Developed in conversations with mathematicians, these formulas are the equivalents of ideas I'd had about the future and the current state of contemporary existence. On one of the tables, for instance, I have put the "Curve for Exponentially Dampened Decay." It means that things get better and things get worse, but always a little less better and a little less worse.

Although it's not a true maze,
this piece does have the word "Maze" extended through it in a mazelike fashion. The word "Muse," in the structure above it, is filled with objects from different sets and in different states. Objects in wood are the most mundane; objects in white are transitional; objects which are transparent are about memory. The sets have to do with contemporary life. So there's a set of objects that has to do with recreation, another of home electronics (radios, televisions). There are pets, food, hats; there's a Joseph Beuys hat, a "Good Guy" white cowboy hat. I use photofloods to indicate self-consciousness, the state of being observed, as I did in "Adventures in the Painted Desert."

The objects are arranged as in a supermarket or grocery store. You go in and encounter endless relational permutations of these objects as you move through the piece, an experience that is much like the unpredictable variety of events you encounter in the course of a day. And as you encounter them, they spin off different classes of meanings and require different solutions to the problems they present.

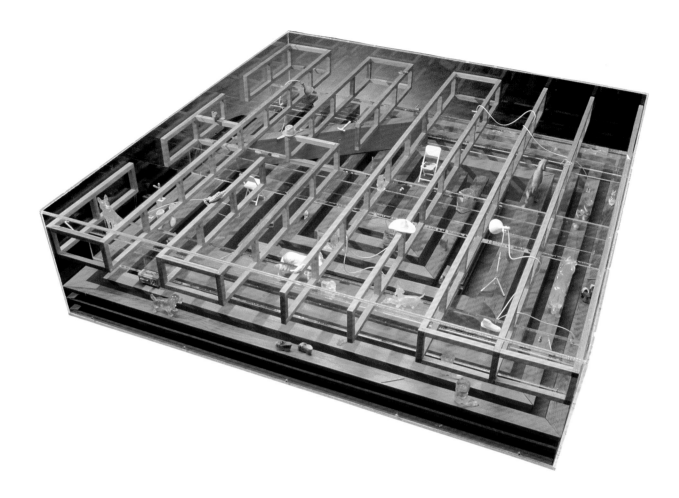

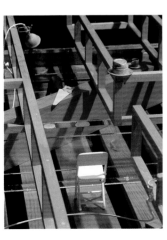

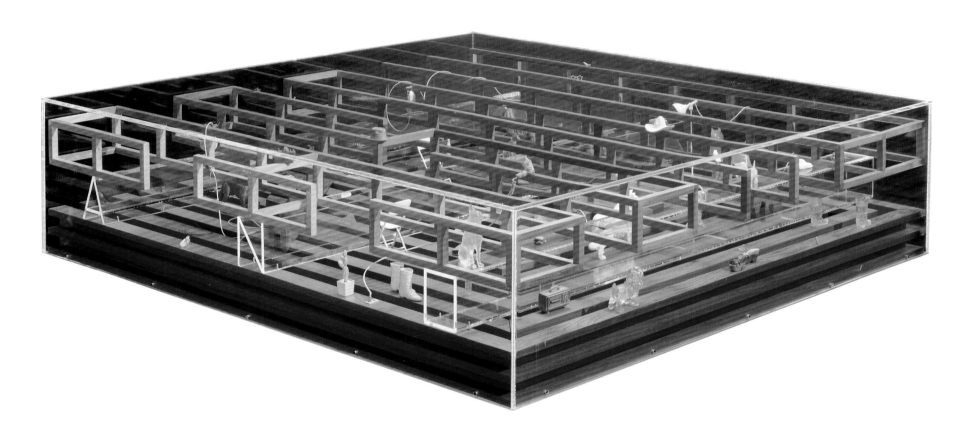

Philosophical Homilies: Amuse and Amaze

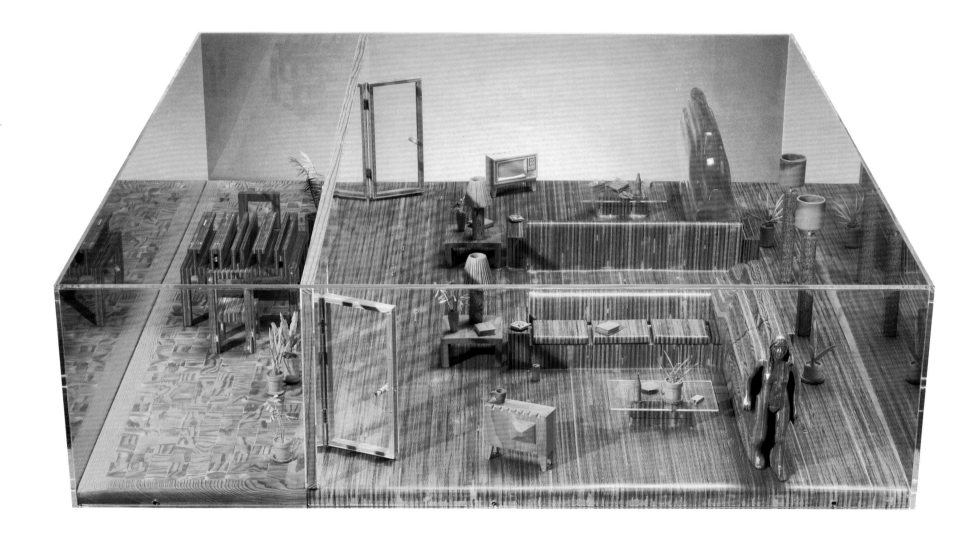

Philosophical Homilies: The Truth Table

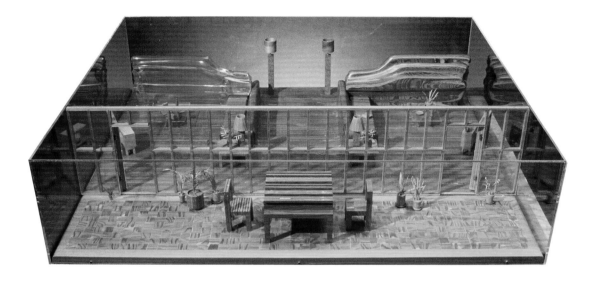

"The Truth Table" came out of my thinking about parallel realities. There are two living rooms and a kitchen area all made out of plywood slats. The two living rooms are slightly different. The conceit is that there would be slippage between the two realities — they couldn't be absolutely identical. And the idea is that from either reality you can enter the kitchen and sit at the truth table. If you sit in the right chair, you can read the word "truth." But if you sit in the wrong chair, "truth" is backwards. So you can sit with or against the (wood) grain.

In the back of the piece are the shapes of two figures who have been sitting in the living room sofas, then get up and move. I'm trying to indicate here that movement in time and space describes sculptural form.

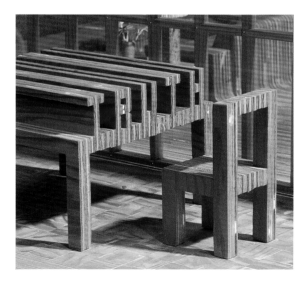

I mean by the title to refer to those
forces that play around the center. The
piece has two architectural sides and a
space between their walls. On one side is
the studio of someone who has abandoned
painting. It's a failed artist, a failed painter,
it may even be me. On the other side, the
white drywall studio is being painted black
and turquoise by some young artist who's
filling the structure with deco furniture and
other studio appurtenances. Between the
two is the studio of the "real" artist, a
secret studio. This is the artist who is at
the center, the true artist, the one who in
the face of changing fashions, in the face
of all the temporal superficiality around
him or her, keeps on painting.

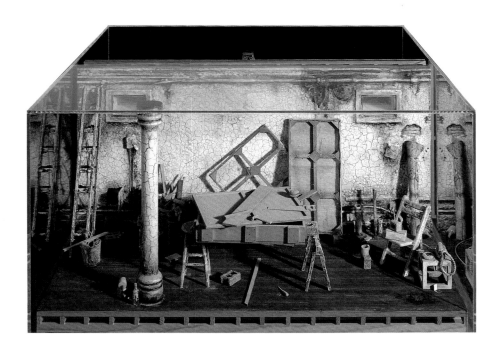

The Dancing Lessons:
Centrifugal Forces

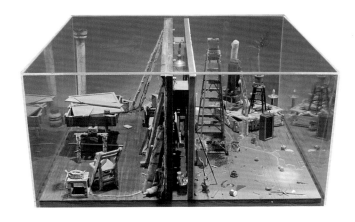

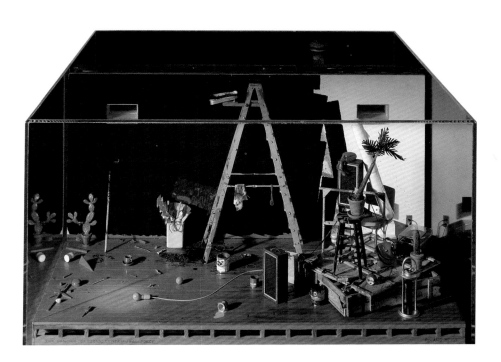

The Dancing Lessons: Physical and Metaphysical Rhythms

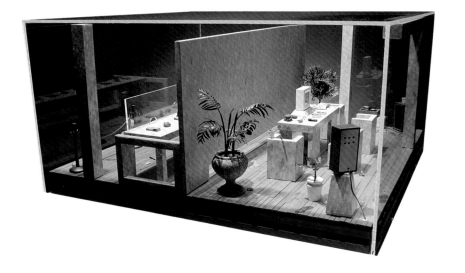 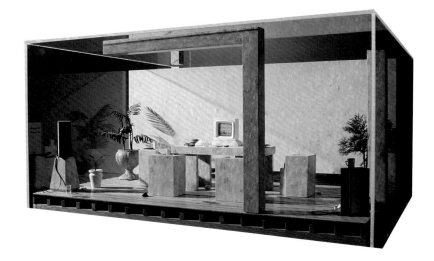

I chose the metaphor of the dancing lesson as something that would kick out into all avenues of contemporary experience, but there was only one real dance studio in the series. In the other pieces, the dance floor, the performance floor, becomes the substructure on which a different reality is played out.

In this piece, we are doing the Bank Dance. It is about financial security and insecurity; paying the piper. Standing too long in line here may be a danger to social health. Institutions of power such as banks, halls of justice and corporate headquarters are often clad in marble in order to evoke a state of reverence and confidence. The bankers' lives, hidden from us on the other side of the wall, turn out to be identical to our own.

On the surface it all appears to be about commerce and survival, but the security camera watches everyone and it suggests that the dance is really about greed, suspicion and trust.

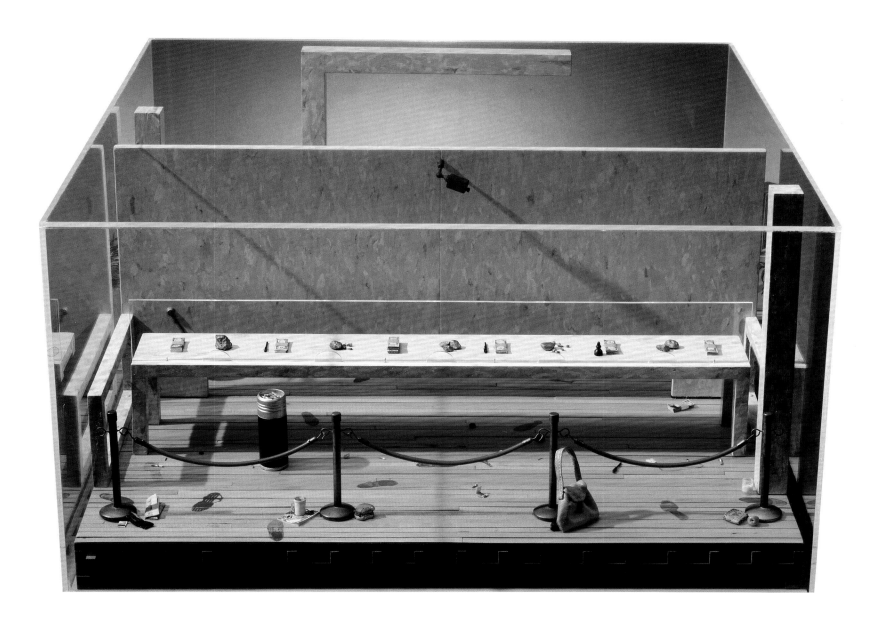

"Keeping Time" is about the dance of art history. The student's chair is surrounded by art history books and notes. If you're seated in that chair and you look out through the columns, you see the entire history of art, including steel beam sculpture, feminist art, video art, etc. I have an obscenity written on the slide screen in Classical Greek. I like that because even art historians usually can't decipher it! I believe that on one level or another, history remains a mystery to all of us.

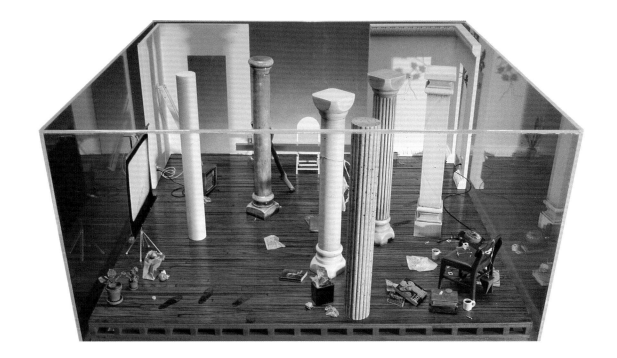

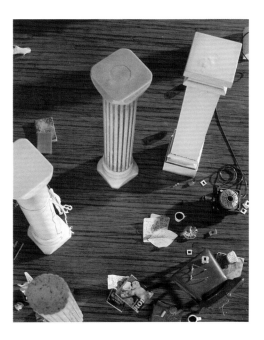

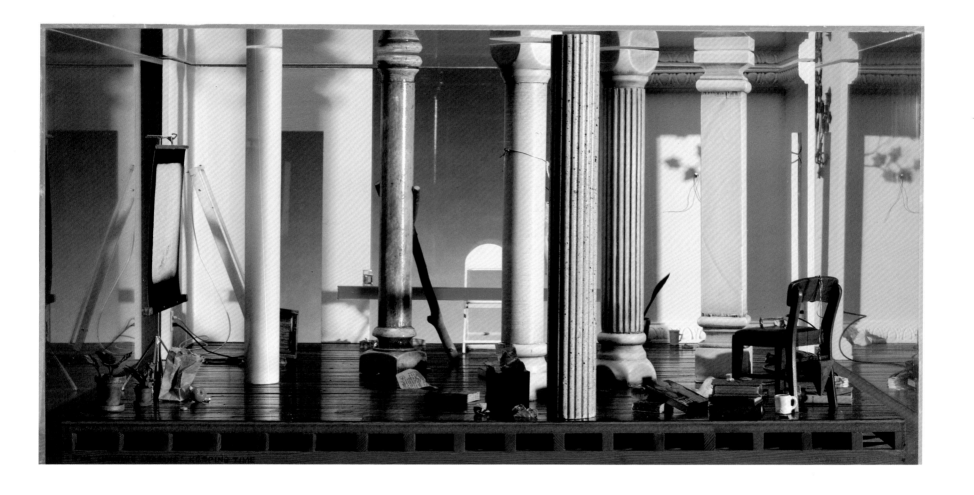

The Dancing Lessons: Keeping Time

Each "Morality Play" deals with the different ways in which middle class American families find meaning in life. Each piece in the series shows both what is common between families and what is different. We share all of these experiences. Either they've been part of our own lives or we've known people who've lived in these ways.

"The Need for Certainty" is about the family which finds meaning in life by traveling. They're always on the go. So there are suitcases, clothing and hair dryers, evidence of preparations to leave, or of having just arrived. The books and souvenirs on the shelves indicate they've traveled widely around the world. Golf clubs and skis indicate the kind of recreation they're interested in on all those trips.

Each "Morality Play" includes a whole group of signifiers, like running shoes to indicate upbeat living, and a safe with money spilling out of it suggesting that our values have been developed in a condition of affluence. The names of vices and virtues are written on columns lying around the living room, allowing you to contemplate the meanings of these values in your life.

The whole series started with the notion that we have short-circuited the meaning of values. I had read medieval descriptions of virtues and vices which were unbelievably extensive. Something like gluttony took up twenty pages. And we now think it simply means "overeating"!

I have no answer to the question of values. I simply wanted to present the current state of family values for contemplation so that we might see where things are going right and where they are going wrong.

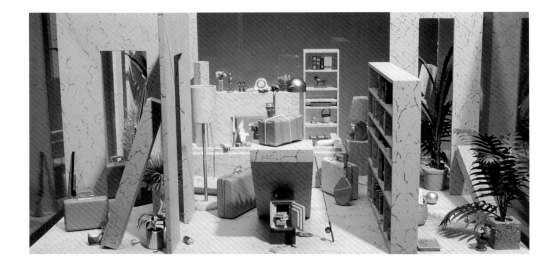

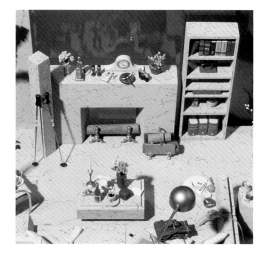

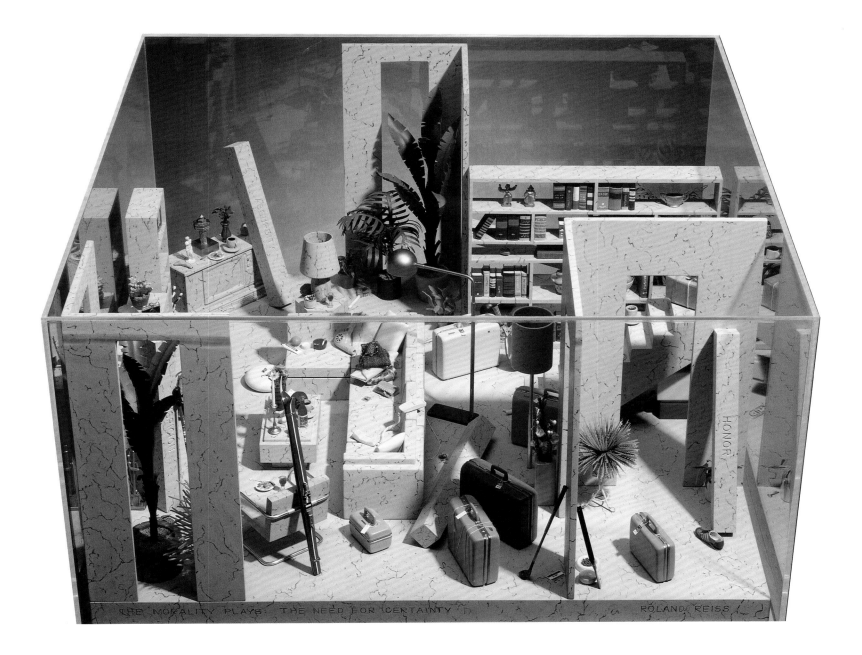

The Morality Plays: The Need for Certainty

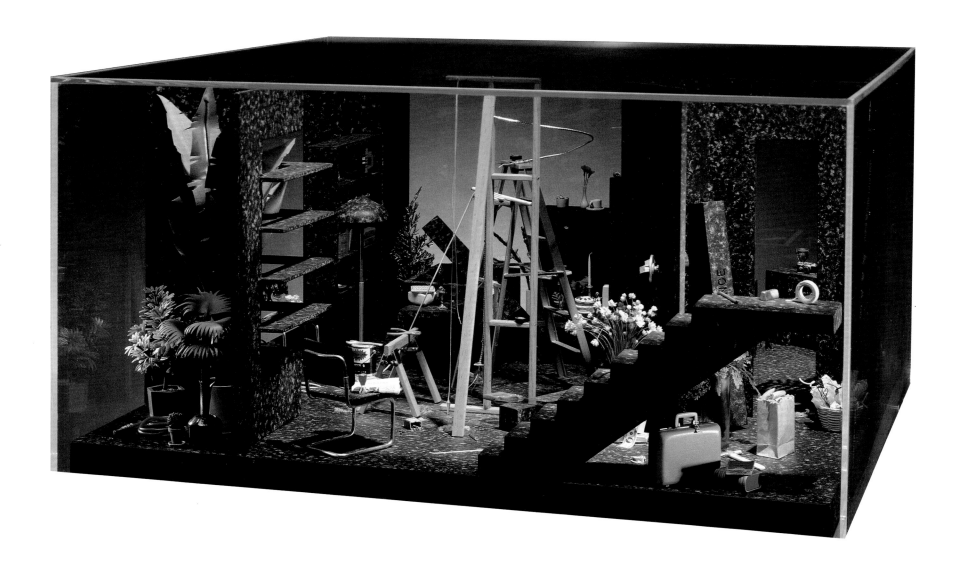

The Morality Plays: The Measure of Moral Phenomena

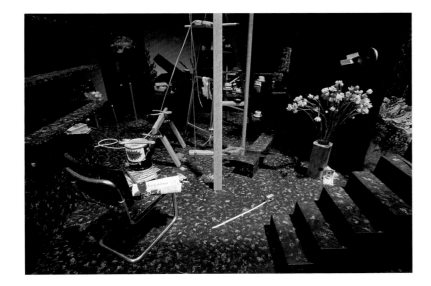

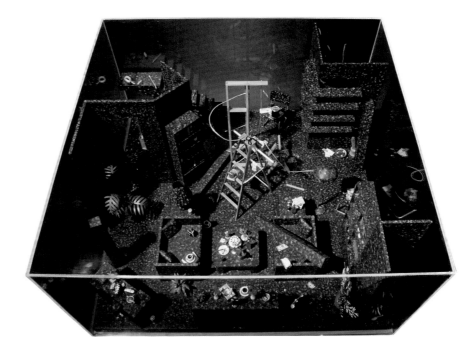

This is another contemplation of middle class American life and of how a family finds
meaning. This family's major activity is remodeling. You know, they think, "Maybe things would be
better if perhaps we'd build a carport, or maybe a new den, or an extra bedroom." So construction is
going on right in their living room. They are also collectors, so they have odd combinations of things on
their mantle, like a Mexican burro and a statue of Napoleon. All the other signifiers are repeated here,
including the gun or knife to indicate violence, because we do not feel secure in our homes.

The "Adult Fairy Tales" are open-ended scenarios about corporate office behavior as set off by particular situations. In the case of "Migration of Thought," we have a woman executive seated at a table with three employees, representing different generations. They are apparently there to provide her with information for a decision. The phone is off the hook on her desk: she obviously has to move information or make a decision right away.

There's a saw leaning against a chair in this piece. The saw alludes to a whole other form of physical work, of manual labor, as opposed to the kind of work that goes on in the corporate office. On the floor and painted the same color as the floor is a corporate sculpture to indicate that such sculpture often disappears into its environment. Each of the "Adult Fairy Tales I" was painted in a single color to suggest the energy state or mental condition present in each room. This color effect abstracts the environment in such a way that you can relate it more specifically to the social interactions taking place within it.

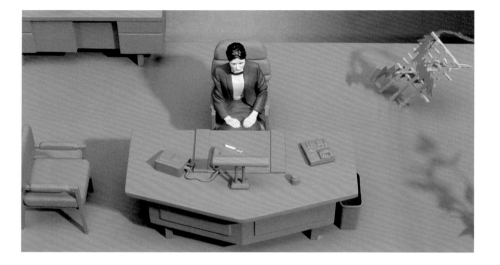

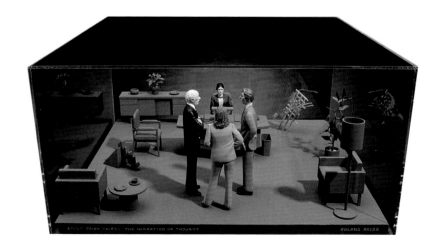

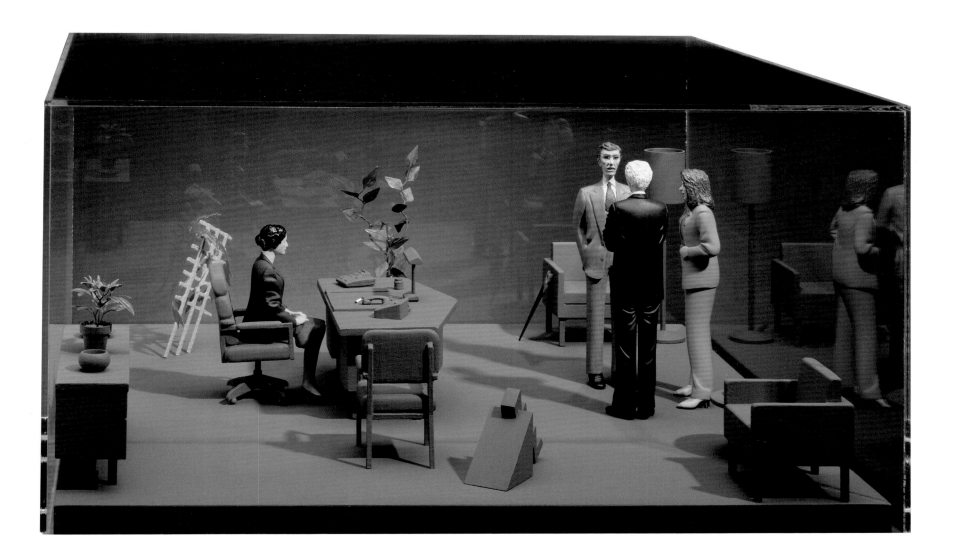

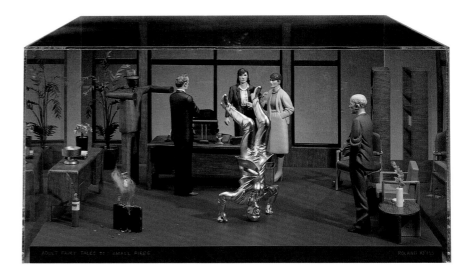

In "Adult Fairy Tales II," I made the environments much more realistic. The furniture and floor are no longer coded to one color. I've included in each a stiff wooden figure, which is a corporate logo figure signaling the corporation's response to whatever's going on in the room. This particular piece is about invisibility. This man is going through a horrible emotional crisis in the presence of other people who are totally oblivious to what is happening. There is a burning notebook and a burning briefcase to indicate there is some terrible crisis taking place. The lone male figure knows this, but the others are still unaware. He's standing there apparently relaxed to attain more invisibility. And he's represented a second time, in robotlike silver and upside down, to show how he really feels. We all go through life experiencing emotional crises which remain largely or entirely invisible to others.

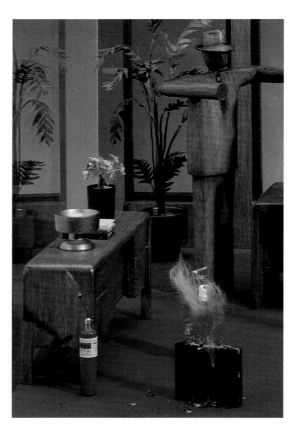

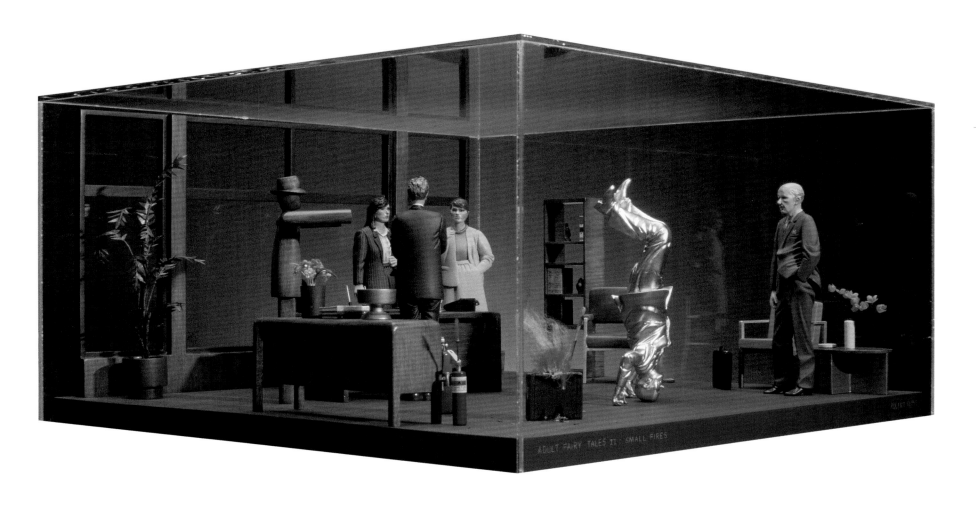

Adult Fairy Tales II: Small Fires

This is about the woman in the workplace, in the
midst of the "good ole boy" system's treatment of the woman as
a sexual object. I've presented her nude, but painted her a power
color: she's a brilliant red. I mean to indicate she does go through
this stuff, but she has her strength. She's not pink, you under-
stand. She's not blushing, she's a really powerful red.

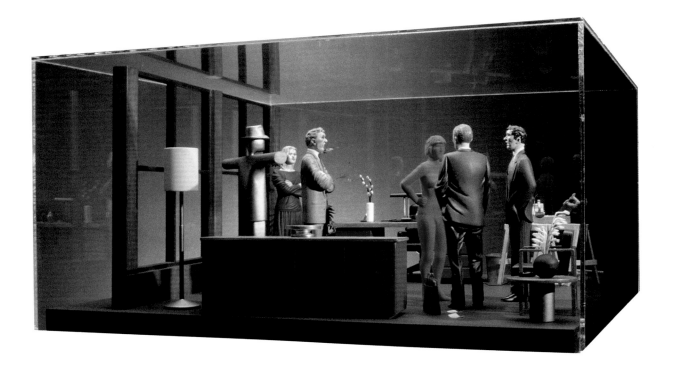

Adult Fairy Tales II: Personal Focus

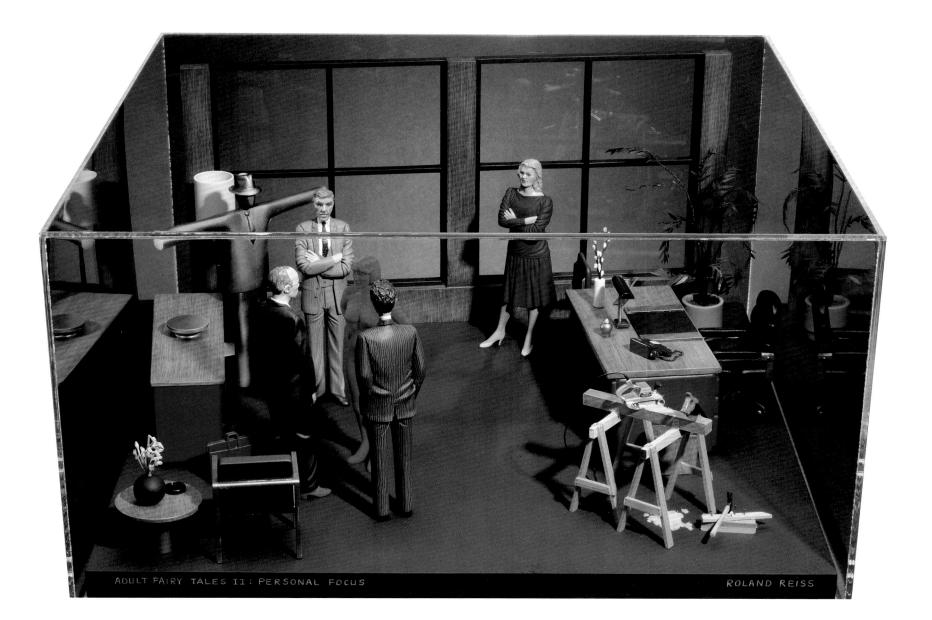

ADULT FAIRY TALES II: PERSONAL FOCUS ROLAND REISS

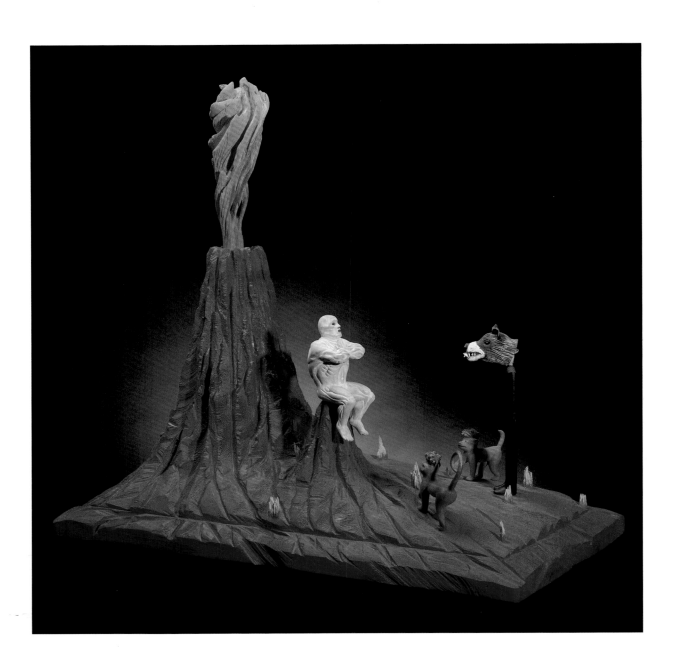

"Keeper of the Fire" deals with our false sense of invulnerability in the face of greater forces in the universe—like nature. The central figure, a white wrestler who appears to be incredibly strong and muscular, is confronting stand-ins for humanity: a business man in a bear mask and two baboons. While he presents his muscles to them, a volcano is blowing its top behind him and will soon engulf them all. This is about our sense of power and how pitifully small it is in comparison to the universe. While we are sometimes arrogant enough to believe that we control nature, we are reminded by natural catastrophes that the fact is otherwise.

My personal sense of this idea comes from my experience of earthquakes in California.

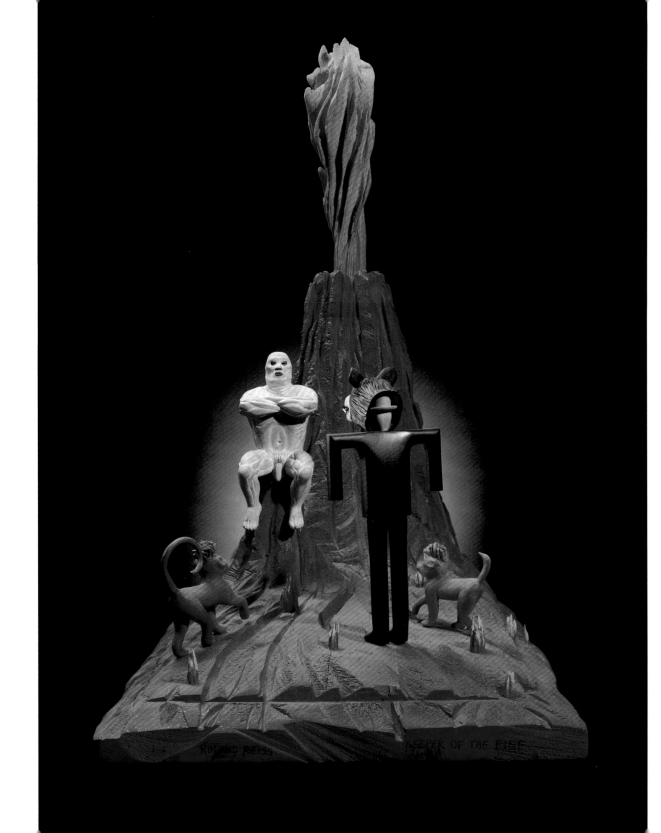

"Revelations" was set off by a quote from the Book of Revelations about the angels who hold the key to the bottomless pit and have to let the devil loose every once in a while. That seems to me to be a terrible responsibility. In my piece, the angels who are responsible for this awesome duty are not very good at anything, not even at being angels. They fly backward, they're awkward and ungainly, unable to make their way out of the trees. I guess in a larger sense the piece is about good and evil and the difficulty we experience in carrying out our serious responsibilities.

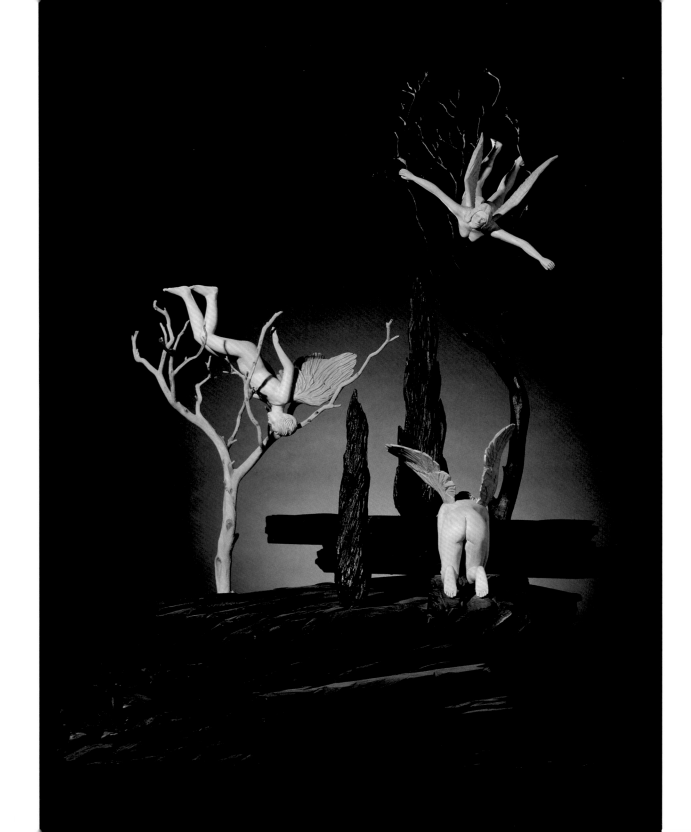

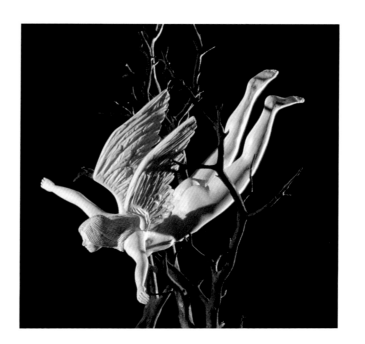

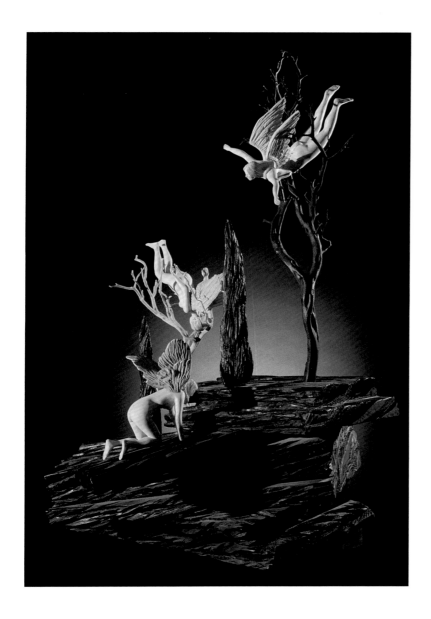

History Lessons: Revelations

"China Dreams: The Opium Wars"
deals with the fantasies and illusions we have about other cultures. I chose the Chinese because my own illusions about Asian culture have been more off base and more bizarre than my illusions about any other cultures.

"China Dreams" is really about the grand adventure, the quest to know the truth about another culture and its view of the nature of existence, to know its politics, its religion. So there's allusion to Confucius, to Buddhism, and this is all interlaced with political history. There's an American gun boat arriving at the (yellow) shore. The boat refers to the conquest of the East by the West. It has been shelling the shore, so there are little explosions happening. The land has opium poppies growing on it and a big Great Wall of China. The figures represent the Oriental menace. One waves a sickle to signal communism and to ward off the arrival of Western Imperialists.

The piece is about our confrontation with images we construct of other cultures, how our view of things so totally distorts their true nature. Like how our view of communism totally distorted our view of Russia. And how our view of Iraq made the war possible ...

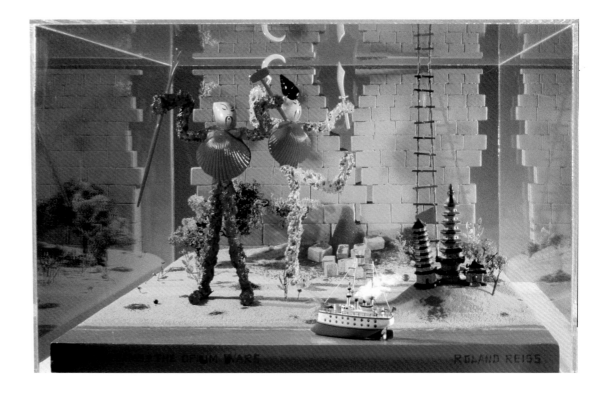

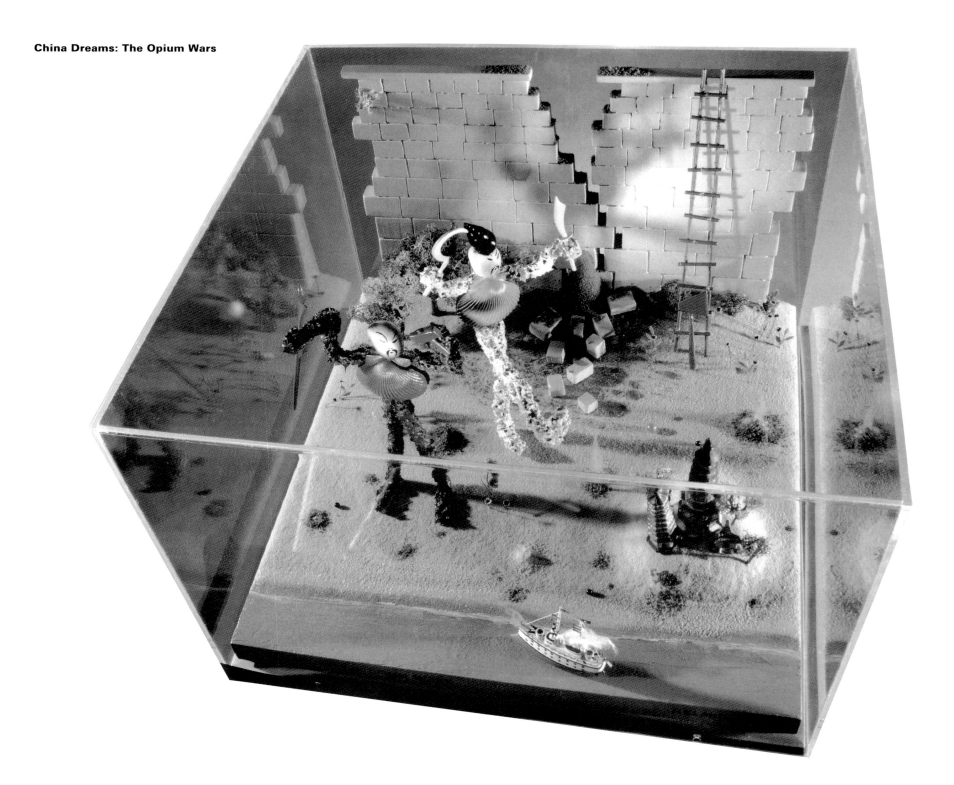

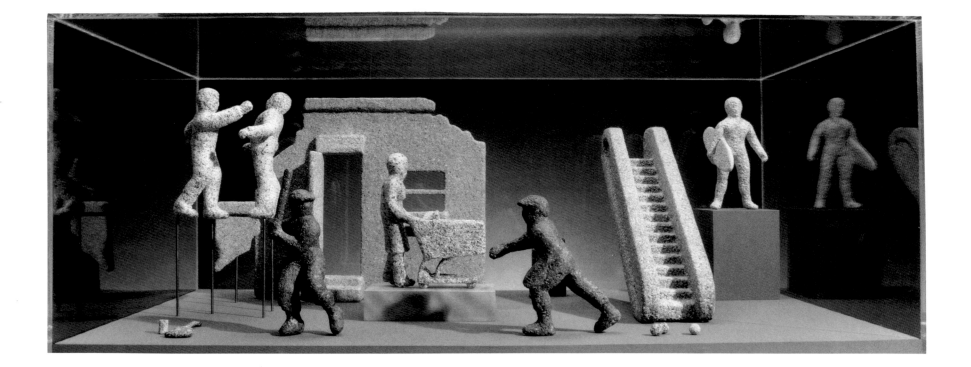

The "New World Stoneworks" series is a fantasy about art which portrays our culture being discovered as archaeological artifact some time in the distant future. We can't see our lives any more clearly now than anthropologists can see the way people lived in the past. Artifacts are often misunderstood and misinterpreted. So I've mislabeled a number of elements intentionally. The "Man With Fish" is really a surfer. The escalator is labeled "War Machine" and is an ironic comment on how our cultural predispositions affect our ability to perceive things correctly. The woman with a shopping cart is a "Votive Offering Figure," thus confusing the secular with the sacred.

What I meant to do with this series is to examine the idea that we don't really know who we are in the context of history and that history has no fixed meaning. These figures and fragments portray us in terms of our activities. We know who we are by what we do, or do we? If two figures who are fighting are misread as dancers, we perhaps have a serious flaw in our ability to solve current social problems.

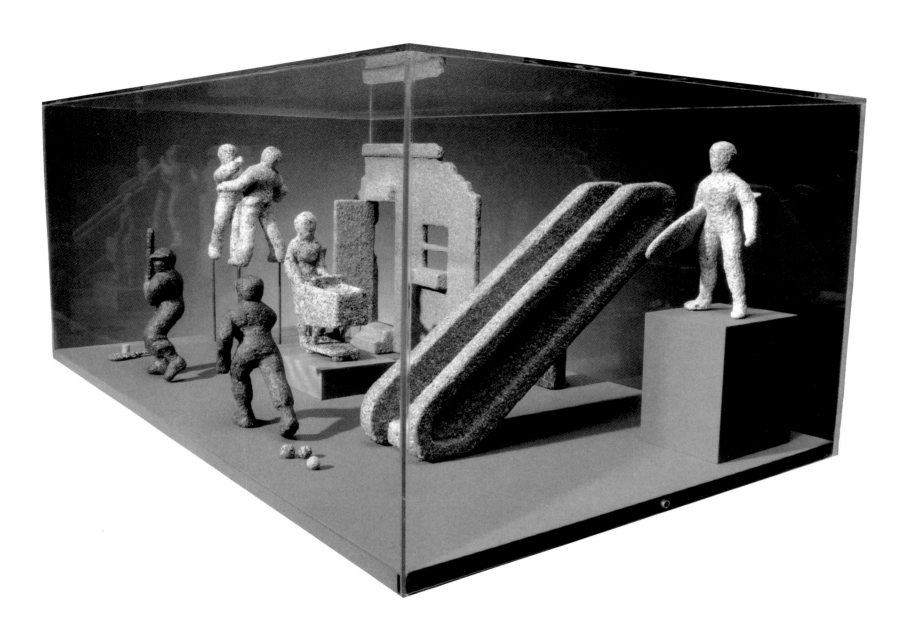

The "Metroman" series is about life
in the city. Of my work, the "Metroman"
figures are the closest to actual life scale.
I felt I could do them in life scale because
they're the least realistic figures I've made.
I really want them to be the exteriorized
personae of people in the city. The figures
are composed of what we create—
sidewalks, buildings, bridges, skyscrapers.
The idea is that we create the city and the
city creates us. I started the series when
I moved to downtown Los Angeles. I
was visiting corporations and walking the
crowded, run-down streets a lot. I saw
people sleeping on the sidewalks, realized
we incorporate the sidewalks into our
bodies.

People are the city; they're also building it,
constructing it. But the city is decaying as
it's being built. The infrastructure is falling
apart. In a funny way, this materialistic
growth and human decay are being pitted
against each other. A positive surge of
construction, then the crumbling; the
polarities of being constructed and decon-
structed. It signals our responsibility for
the urban future.

Many of the figures are set at extreme
angles. This was a way to represent the
extreme danger and dynamism of city life.
After all, the incorporation of all these
elements is bound to have an effect on
the psyche.

Metroman:
Mr. Green

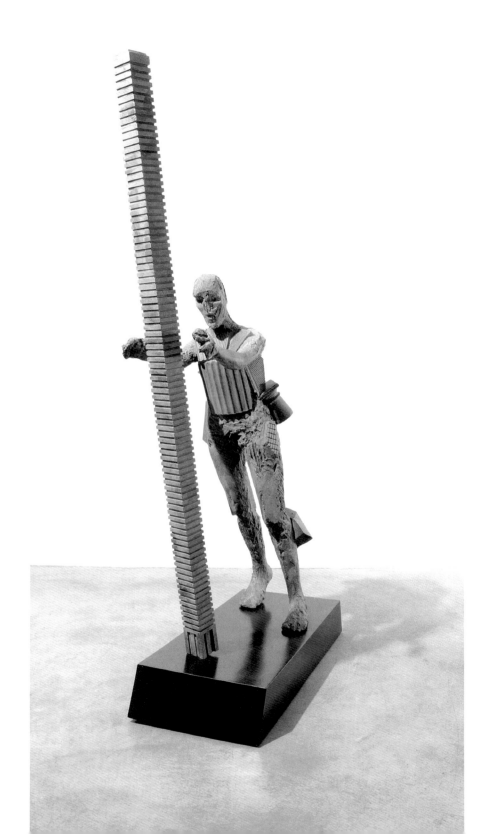

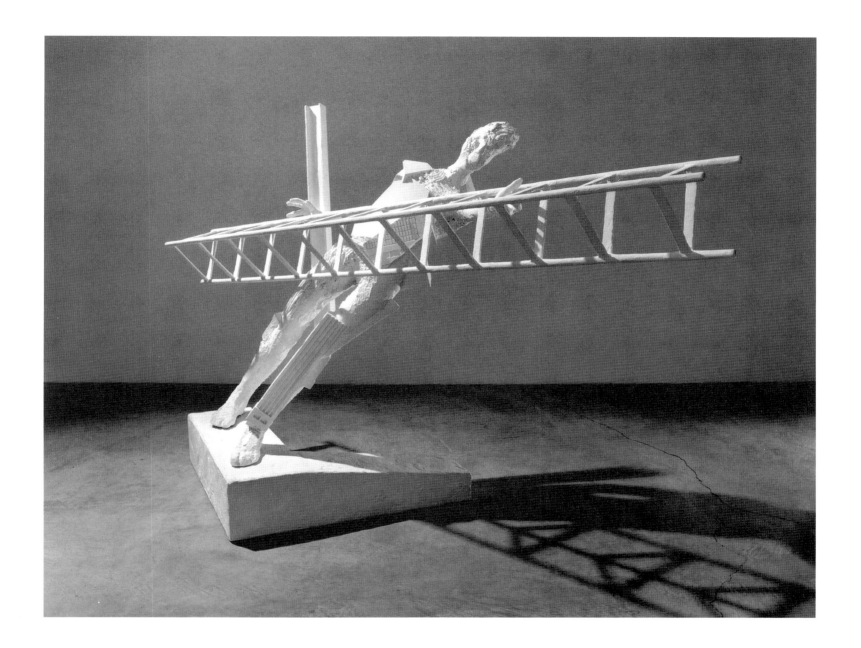

Metroman: Falling White

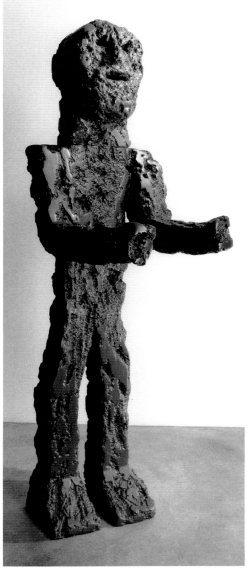

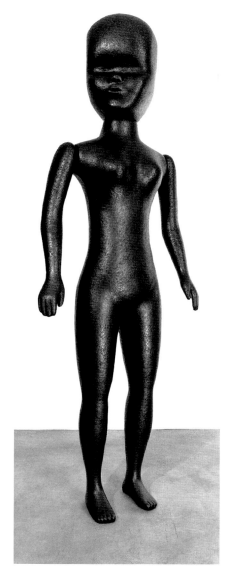

Players: **Yee Mee Loo** **Iron Man** **Pupa**

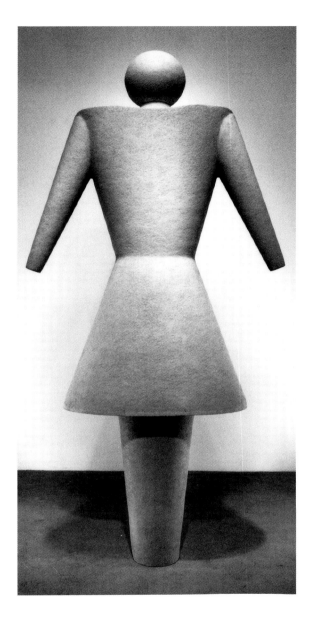

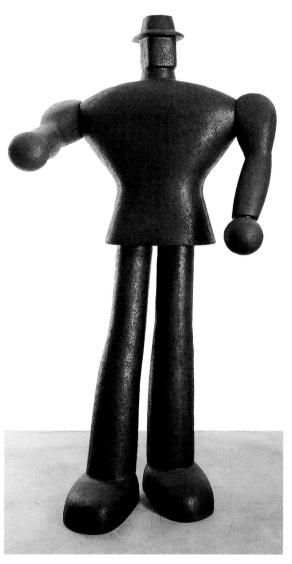

This installation involves a number of figures and a large ball. They're all done in heroic scale, which is defined as "larger than life but not monumental, often somewhat humorous." The Players all play a game around a ball which has gouged in it symbols of contemporary experience, like a rocket, a bird, a guitar. Each Player represents a distinct character known by its style. They are all derived from stylistic properties across the history of art—fine art, popular art, folk art. I mix them all. And they are not necessarily pleasant characters. "Generis" is the generic woman. As a Player, she raises the whole question of feminism. "Iron Man" is derived from a figure which has existed from prehistory forward and is found in virtually every culture in some form or other. He is meant to represent the rude masculine projection of strength. He's another version of the "wild man." "Hero" is a contemporary business man who's filled out in muscular proportions. His physical consciousness is underlined by his general stance; he has robotlike qualities. He's a stereotype; he fills a set of contemporary ideals that ultimately result in stereotypes. His big shoes and ball hands (like boxing gloves) show he's aggressive but contained. You sense that he is totally self-centered.

Generis

Hero

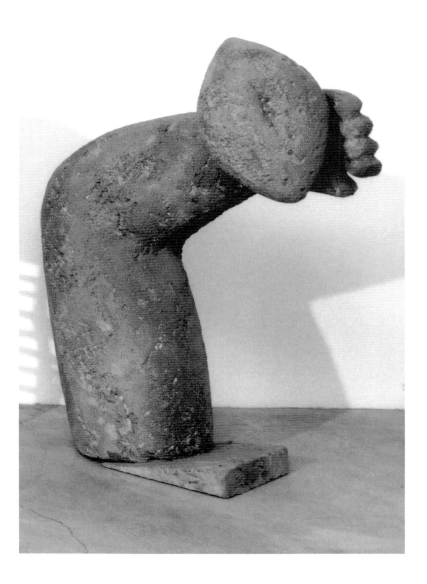

I wanted to deal with how we spend our time, what we do with our lives, with existence. In one extreme, our lives are given to recreation (signified here by the baseball bat, football, basketball, you know, by sports). At the other extreme are spheres which represent our meditation on planets, the cosmos. These extremes of action and thought, play and contemplation are juxtaposed without transition or mediation. It is an exercise in complementarity.

These elements are placed around a monument I've erected, based on the concept of how cultures build on other cultures. Often it involves the recycling of old ideas and materials. Contemporary culture in particular has been estranged from history. Some think history as we have known it is at an end. Certainly, we are confused about it. So my monumental figure is goofy and off. He has a hard time holding himself up and achieving a dignified stance. It's about making monuments of our experience and the strange feeling of superiority we have developed in relation to history. It's about cultural vanity. The ball game, the game of life, is played around our moment in time.

The Ball Game

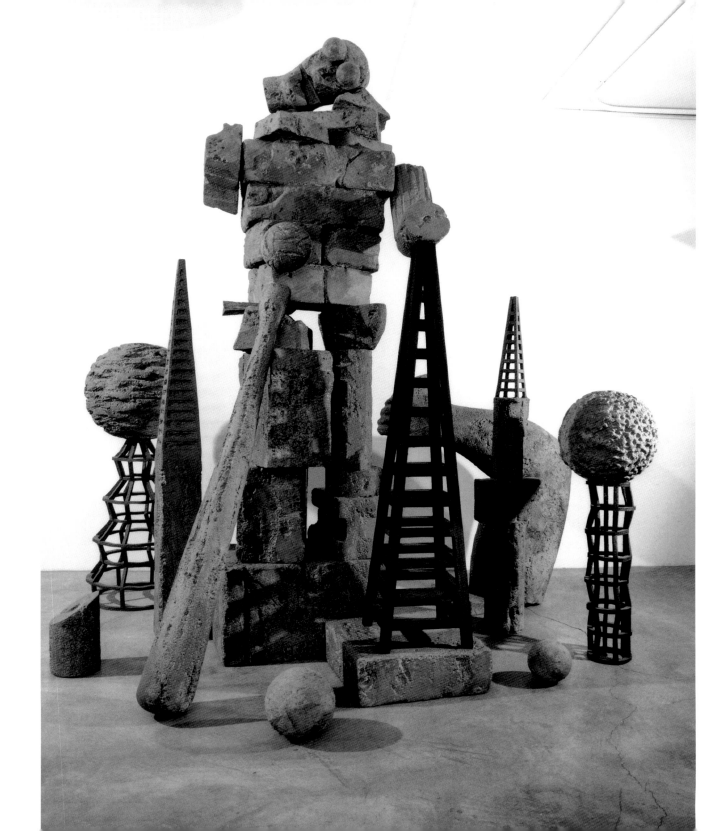

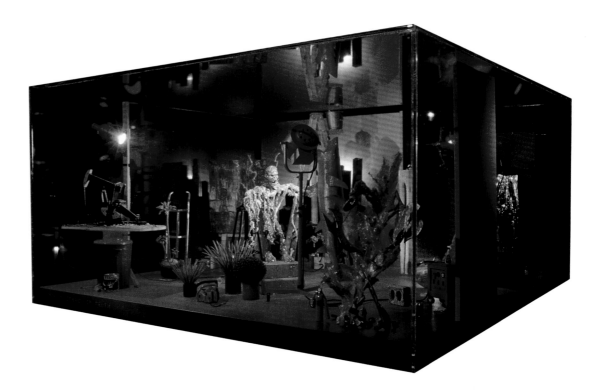

The inspiration for this series goes back to my graduate school days at UCLA. I would look out at the movie studios in Culver City and see a giant blue sky painted on a backdrop, silhouetted against the real sky. I was struck by the artificiality of that experience, by the irony of basing so much of our reality on illusion, of how we even develop our hopes and fears out of such simulations …

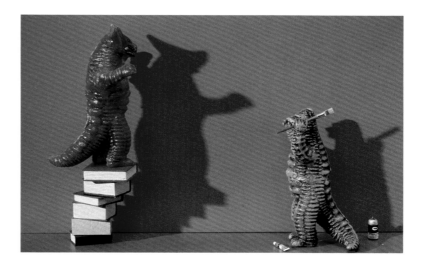

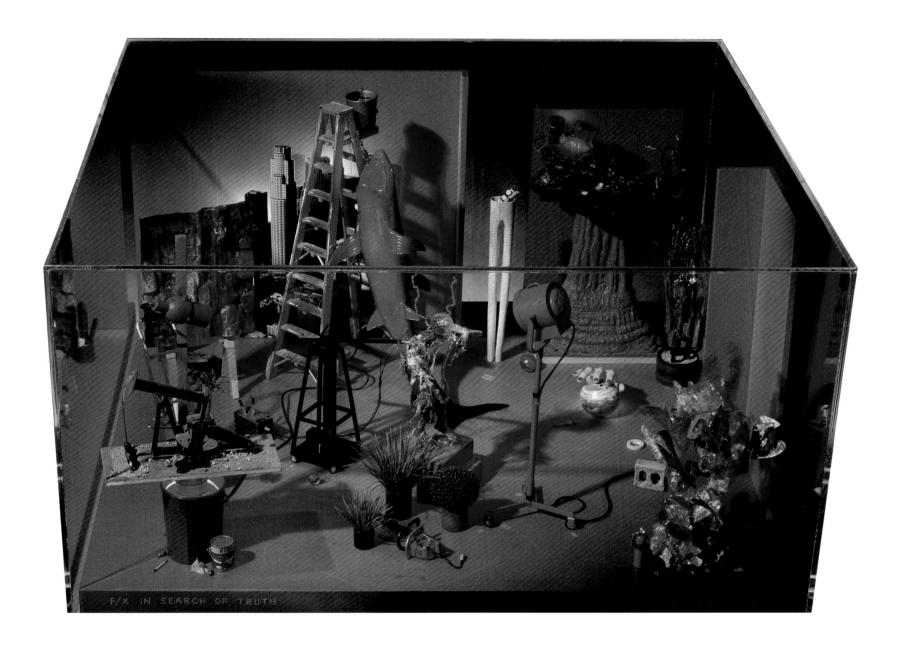

F/X: In Search of Truth

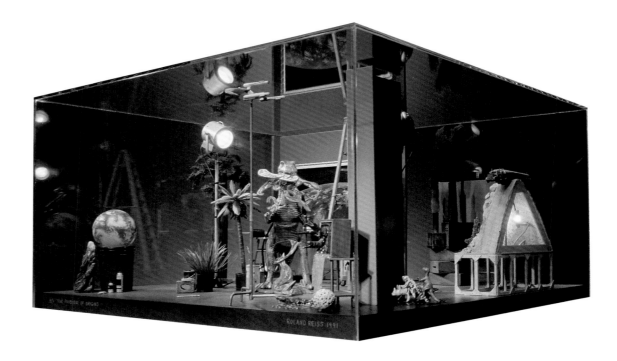

...And I began to realize that these illusions were actually forming a kind of language, forming the cultural myth. They are given to us through the media, through film, television and magazines. They are repeated over and over again and they become major cultural signifiers. At that point, they are quite removed from their original sources. Like the image of the mesa which appears in car commercials, in beer commercials; like images of sharks with voracious open mouths, monsters of all kinds. Then there are seemingly positive images of earth and the planets. What do these things mean in the language of illusion? What myths are we making?

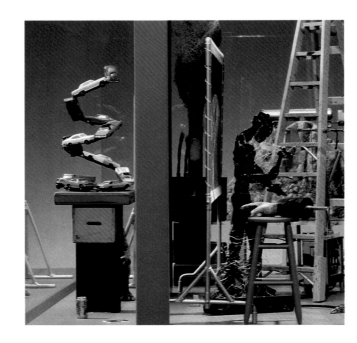

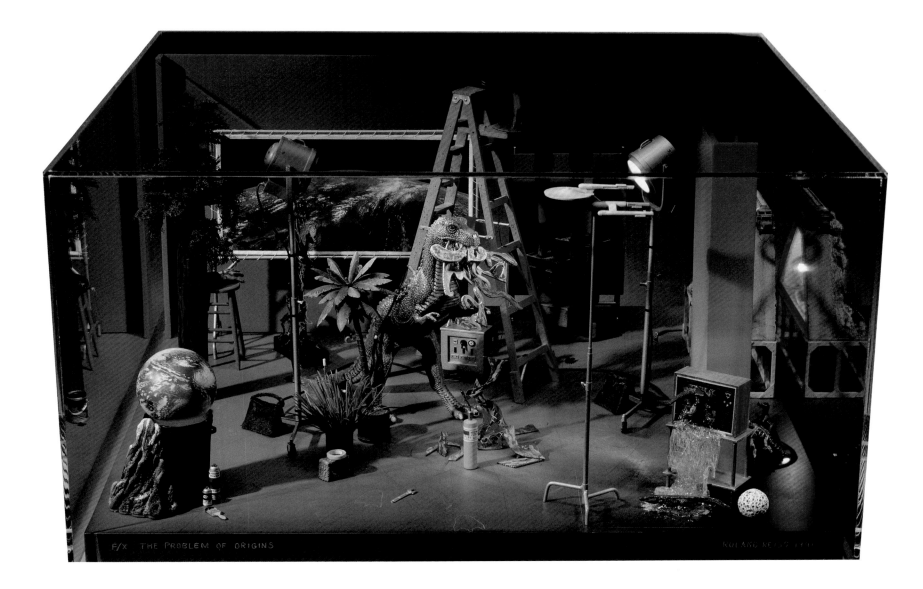

F/X : THE PROBLEM OF ORIGINS

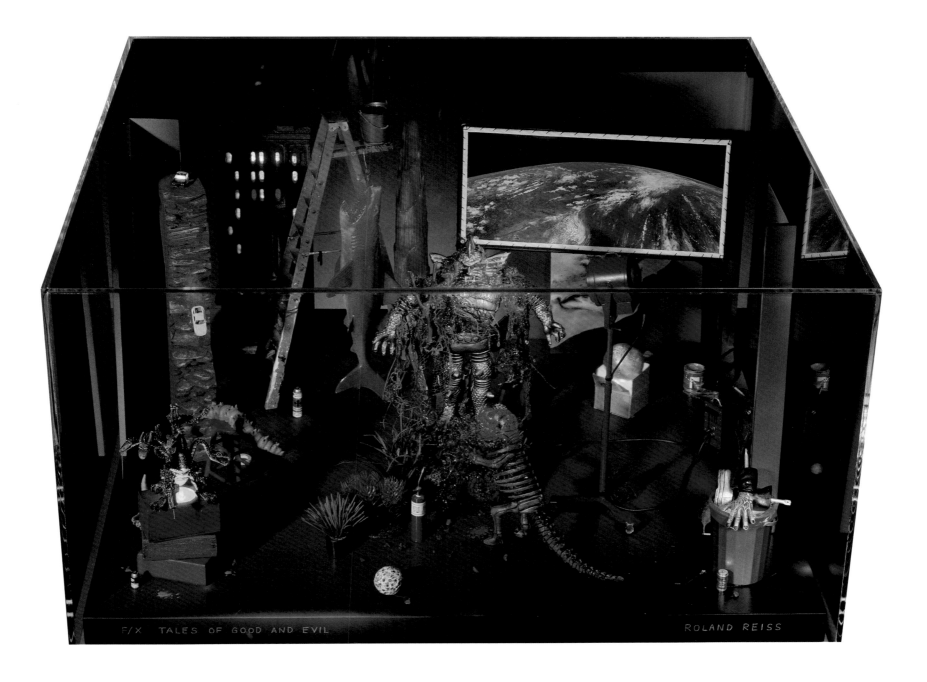

F/X: Tales of Good and Evil

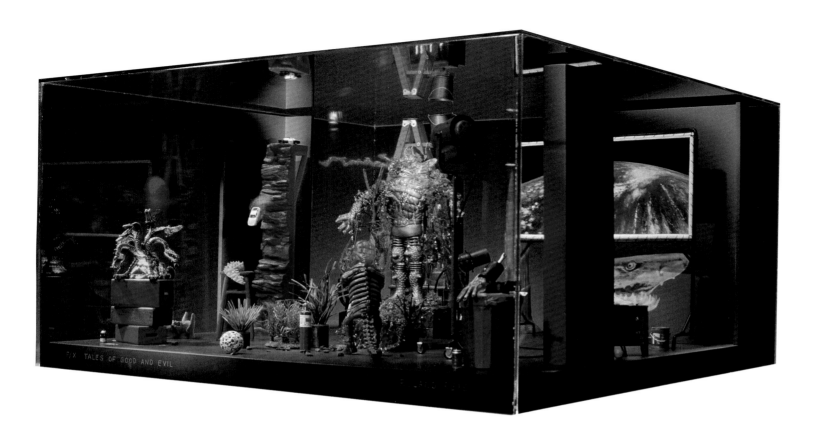

… Just as in the "Morality Plays," I have
no final word or moral judgment. I like to
think I just observe what is going on. Obvi-
ously, I do take positions. Those elements
having to do with ecology and the survival
of the planet are made more prominent.
And I can't depict certain overt aspects of
violence. I feel that if I chose to demon-
strate such violence in my work, I would
be participating in it.

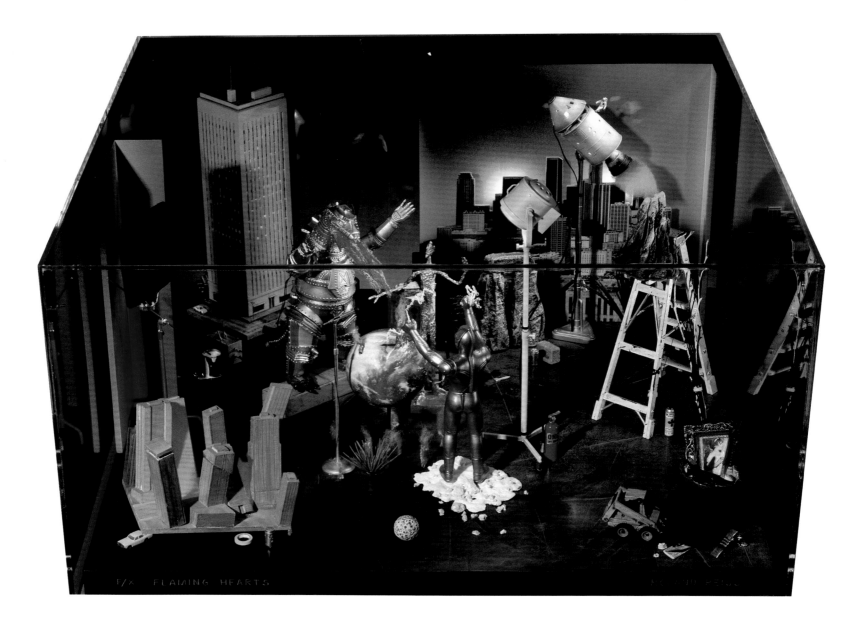

F/X FLAMING HEARTS

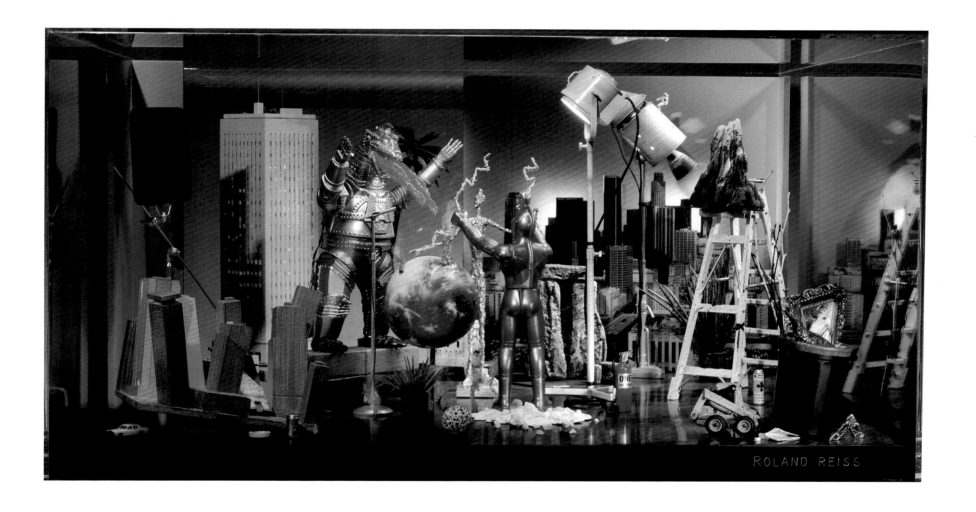

F/X: Double Exposures

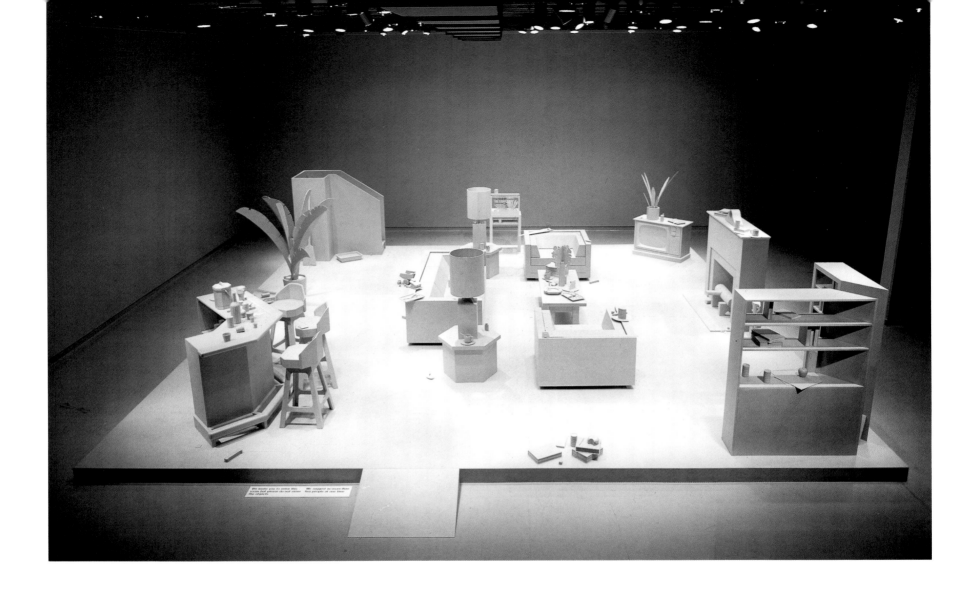

The Castle of Perseverance

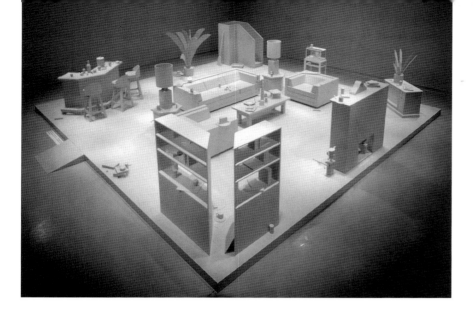

I had a chance to do a "Morality Play" in life scale for a group show of installations at Newport Harbor in 1978. That was of particular interest to me— it was a chance for me and others to experience the difference between my tableaus and life scale. The miniature is automatically experienced as fictional because the scale is reduced. In life scale, things immediately become real. In the small work, you can't sit in a chair. In life scale, you can. So to achieve distance and the abstract mental level of experience I wanted, I decided to do it all in a single material—particle board. The installation became more like an architect's idea projected into three dimensions, or like a full-sized model. Color deprivation was used to encourage a more mental reading of the piece. I wanted it to be a reflective situation, a "slow take" piece in which you walked around and considered the objects and their place in American family life. Why do we need these objects? What do they say about American culture? The overlap of art world and real world continues here. Does the stack of opaque slides tell you an artist lives in this room, or was someone just showing his or her friends the family vacation in Paris?

In "Heat," I wanted to deal with
some contemporary environmental prob-
lems, at least with my version of them.
I also wanted to present a different way
to experience my work. In this case, as
opposed to being able to walk around
in it (as in "The Castle of Perseverance")
or project yourself into the piece mentally
(as in the tableaus), I thought it would be
interesting to center yourself physically
in the sculptural idea. As you stand under
the hanging tableaus, then raise your head
into the opening in each, you become the
center of the problem.

"Heat" is about the city and the energy it
radiates. We see the city as a symbol for
human progress and growth while ignor-
ing its omnivorous appetite for natural
resources and its social destructiveness.
It glows red with combustion caused by
population density and the burning of raw
materials to support its life. The other ele-
ments, the oil spill, the decimated forest,
the lawless street are some of its conse-
quences. It is what we have created and it
is beautiful and ugly at the same time.

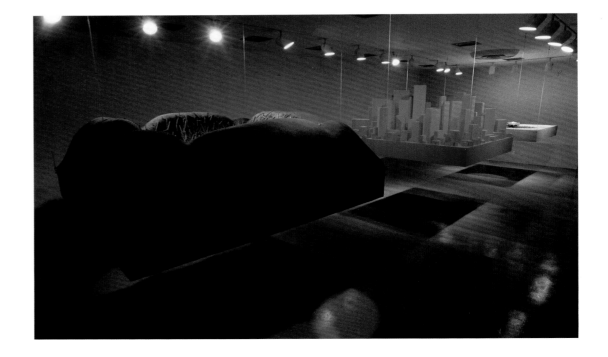

Heat

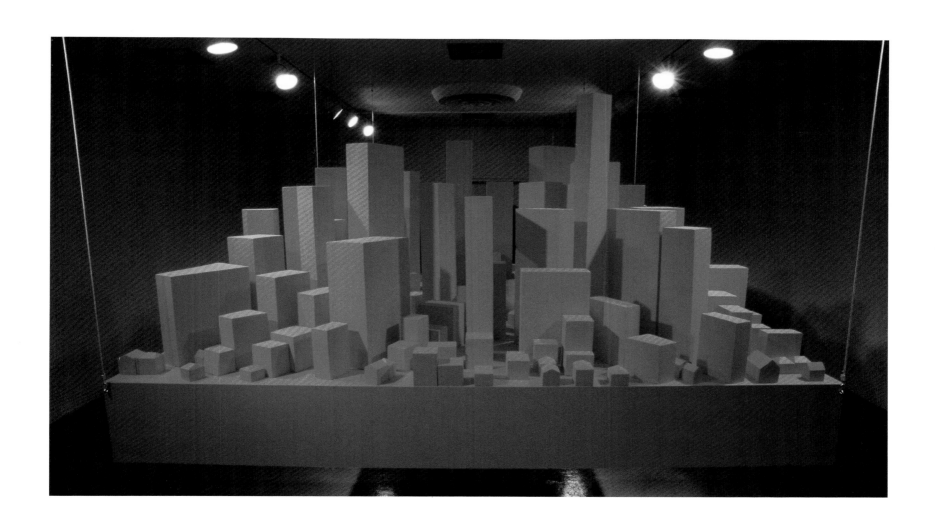

Exhibition Checklist

ALL DIMENSIONS ARE HEIGHT X LENGTH X WIDTH.

Adventures in the Painted Desert: A Murder Mystery
1975, 1' x 4' x 4'
Collection of the University of Arizona Museum of Art; Museum Purchase with funds provided by the Edward J. Gallagher, Jr. Memorial Fund

Easy Turns, Happy Trails: A Murder Mystery
1975, 1' x 3' x 3'
Collection of Museum of Contemporary Art

Philosophical Homilies: Amuse and Amaze
1976, 1' x 4' x 4'
Collection of Los Angeles County Museum of Art

Philosophical Homilies: The Truth Table
1974, 1' x 4' x 4'
Collection of Ruth & Jacob Bloom

The Gravity Observations: I Keep Wondering
1977; 12" x 36" x 10"
Collection of Peter & Ellie Blankfort Clothier

The Gravity Observations: Victory Over Need
1982, 1' x 4' x 4'
Collection of the artist

The Dancing Lessons: Tiny Movements and Small Possibilities
1977, 1' x 2' x 2'
Collection of Daniel Saxon & Channing Chase, Courtesy of Daniel Saxon Gallery, Los Angeles

The Dancing Lessons: Tap Dance Furioso
1978, 1' x 2' x 2'
Collection of Norman Lear

The Dancing Lessons: Centrifugal Forces
1979, 1' x 2' x 2'
Collection of Barry & Gail Berkus

The Dancing Lessons: Physical and Metaphysical Rhythms
1977, 1' x 2' x 2'
Collection of Ruth & Jacob Bloom

The Dancing Lessons: Keeping Time
1977, 1' x 2' x 2'
Collection of Cynthia Monaco

The Dancing Lessons: Simple Awareness
1977, 1' x 2' x 2'
Collection of Jean Milant

The Dancing Lessons: The Movement of the Body & The Movement of the Mind
1977, 12" x 36" x 8"
Collection of Los Angeles County Museum of Art

The Dancing Lessons: The Levitation of Earthbound Entities
1977, 12" x 36" x 8"
Collection of Diana Zlotnick

The Dancing Lessons: Unfinished Business
1977, 1' x 2' x 2'
Collection of the artist

The Morality Plays: The Need for Certainty
1980, 1' x 2' x 2'
Collection of Newport Harbor Art Museum

The Morality Plays: The Measure of Moral Phenomena
1980, 1' x 2' x 2'
Collection of Newport Harbor Art Museum

The Morality Plays: Personal Knowledge
1980, 1' x 2' x 2'
Collection of Newport Harbor Art Museum

The Morality Plays: Truth in the Face of Pressure
1980, 1' x 2' x 2'
Collection of Newport Harbor Art Museum

The Morality Plays: The Origin of Poetry
1980, 12" x 36" x 8"
Collection of The Capital Group, Inc.

The Morality Plays: The Power of Suggestion
1980, 12" x 36" x 8"
Collection of Lura Gard Newhouse

Adult Fairy Tales I: Command Performance
1983, 1' x 2' x 2'
Collection of Mark & Jane Nathanson

Adult Fairy Tales I: Migration of Thought
1983, 1' x 2' x 2'
Collection of The Capital Group, Inc.

Adult Fairy Tales I: Strange Stories
1983, 1' x 2' x 2'
Collection of Ruth & Jacob Bloom

Adult Fairy Tales I: Conventional Wisdom
1983, 1' x 2' x 2'
Collection of Maurice Tuchman

Adult Fairy Tales II: Grounds for Belief
1984, 1' x 2' x 2'
Collection of Marcia & Richard Schulman

Adult Fairy Tales II: Small Fires
1984, 1' x 2' x 2'
Collection of the artist

Adult Fairy Tales II: Personal Focus
1984, 1' x 2' x 2'
Collection of Elaine Horwitch

The Fates: Present Tense

1985, 12" x 30" x 12"

Collection of the artist

History Lessons:
Keeper of the Fire

1986, 30" x 31" x 16"

Collection of the artist

History Lessons: Encounter

1986, 26" x 28" x 13"

Collection of the artist

History Lessons: Revelations

1986, 42" x 33" x 21"

Collection of the artist

China Dreams: The Opium Wars

1982, 1' x 2' x 2'

Collection of Ruth & Jacob Bloom

New World Stoneworks:
L.A. Basin Culture Figures

1981, 21" x 42" x 24"

Collection of Law Offices of Myman,
Abell, Fineman & Greenspan

New World Stoneworks:
L.A. Basin Culture Figures

1981, 21" x 24" x 60"

Collection of Joan & Fred Nicholas

Metroman: Falling Brown

1986, 30" x 60" x 54"

Collection of Barry & Gail Berkus

Metroman: Small Black

1986, 48" x 42" x 24"

Collection of Mr. & Mrs. Eli Luria

Metroman: Falling White

1986, 66" x 96" x 48"

Collection of the artist

Metroman: Mr. Green

1986, 84" x 48" x 19"

Collection of Mandy & Cliff Einstein

Metroman: Builder

1986, 120" x 60" x 54"

Collection of the artist

Metroman: Venus

1986, 7' x 3' x 3'

Collection of Ruth & Jacob Bloom

Players

An installation, 1988–1990

All figures 10' in height

Collection of the artist

The Ball Game

An installation, 1987

Main figure 11' in height

Collection of the artist

Agit

1988, 24" x 29" x 22"

Collection of Law Offices of Myman,
Abell, Fineman & Greenspan

Vapor

1989, 31" x 12" x 24"

Collection of the artist

Gyros

1989, 37" x 24" x 19"

Collection of the artist

Mnemos

1989, 30" x 28" x 18"

Collection of the artist

F/X: Flaming Hearts

1990–1991, 14" x 24" x 24"

Collection of the artist

F/X: In Search of Truth

1990–1991, 14" x 24" x 24"

Collection of the artist

F/X: The Problem of Origins

1990–1991, 14" x 24" x 24"

Collection of the artist

F/X: Tales of Good and Evil

1990–1991, 14" x 24" x 24"

Collection of the artist

F/X: Double Exposures

1991, 14" x 24" x 24"

Collection of the artist

The Castle of Perseverance

An installation, 1978

Approximately 29' x 29'

Collection of the artist

Heat

An installation, 1990–1991

Four units, each 2' x 7' x 7'

Collection of the artist

Resume Vita

University Education

University of California, Los Angeles (UCLA)

American Academy of Art, Chicago, IL

Mount San Antonio College, Walnut, CA

Degrees

Master of Arts, UCLA, 1957

Bachelor of Arts, UCLA, 1955

Teaching

Chairman, Department of Art, Claremont Graduate School, Claremont, CA 1971–present

University of Colorado, Boulder, CO 1957–1971

University of California, Los Angeles, CA 1957

Grants

NEA Visual Artists Fellowship, sculpture 1986–87

NEA Visual Artists Fellowship, sculpture 1979–80

NEA Visual Artists Fellowship, sculpture 1975–77

NEA Visual Artists Fellowship, sculpture 1970–71

Selected Exhibitions

1991

"Roland Reiss: A Seventeen Year Survey," Los Angeles Municipal Art Gallery, Barnsdall Park, Los Angeles, CA

"Individual Realities," Sezon Museum of Art, Tokyo/Tsukashin Hall, Osaka, Japan

"The Play in Art," Irvine Fine Arts Center, Irvine, CA

1990

"Heat," Pasadena City College Art Gallery, Pasadena, CA

Group exhibition, Idyllwild School of Music and the Arts Gallery, Idyllwild, CA

"Crossing the Line: Word and Image in Art, 1960–1990," Galleries of the Claremont Colleges, Claremont, CA

1989

Group exhibition, Ace Contemporary Exhibitions, Los Angeles, CA

Group exhibition, Madrone Gallery, San Pedro, CA

"Inside the L.A. Artist," Boritzer-Gray Gallery, Los Angeles, CA

Group exhibition, Idyllwild School of Music and the Arts Gallery, Idyllwild, CA

1988

One person exhibition, Ace Contemporary Exhibitions, Los Angeles, CA

"Lost and Found in California, Four Decades of Assemblage Art," Shoshana Wayne and James Corcoran Galleries, Santa Monica, CA

"Social Satire: A Commentary on Modern Times," Saxon Lee Gallery, Los Angeles, CA

"Art in Los Angeles 1988, Profound Visions," Ace Contemporary Exhibitions, Los Angeles, CA

"Portraits: Here's Looking at You," The Anchorage Museum of Art, Anchorage, AK

"Small Scale Sculpture," Merging One Gallery, Santa Monica, CA

"Relationships," Hippodrome Gallery, Long Beach, CA

1987

"Avant Garde in the '80s," Los Angeles County Museum of Art, Los Angeles, CA

"Intimate Environments," McIntosh/Drysdale Gallery, Washington, D.C.

"Contemporary Southern California Art," Los Angeles Municipal Art Gallery, Barnsdall Park, Los Angeles, CA/Taipei Fine Arts Museum, Taipei, Taiwan

"Personal Iconography," Gallery at the Plaza, Security Pacific National Bank, Los Angeles, CA/Taipei Fine Arts Museum, Taipei, Taiwan

One person exhibition, Sierra Nevada Museum, Reno, NV

Group exhibition, San Jose Institute of Contemporary Art, San Jose, CA

One person exhibition, Rena Bransten Gallery, San Francisco, CA

"The Ball Game," (One person exhibition), Ace Contemporary Exhibitions, Los Angeles, CA

"Contemporary Bronze," California State University, San Bernardino, CA

"California Figurative Sculpture," Palm Springs Desert Museum, Palm Springs, CA

"Art in Los Angeles," Cirrus Gallery, Los Angeles, CA

1986

One person exhibition, Flow Ace Gallery, Los Angeles, CA

"Through the Eyes of an Artist," Loyola Marymount University, Los Angeles, CA

"Transcending Confines," Matrix Gallery, Sacramento, CA

"Interior: The Home/Exterior: The Landscape," Wita Gardiner Gallery, San Diego, CA

"Roland Reiss," Mount San Antonio College, Walnut, CA

"Fictional L.A." Art Space Gallery, San Francisco, CA

"Personal Environments," Museum of Fine Arts, Santa Fe, NM

"The Continuing Magic of California Assemblage," California State University, Dominguez Hills, CA

1985

"Boxes," Museo Tamayo, Mexico City, Mexico

"California Painting and Sculpture," Gallery at the Plaza, Security Pacific National Bank, Los Angeles, CA

"Artists Look at Architecture," Transamerica Corporation, San Francisco, CA

"Desert Collections," Palm Springs Desert Museum, Palm Springs, CA

"Adult Fairy Tales," Elaine Horwich Gallery, Scottsdale, AZ

1984

"Four Sculptors From The West: Reiss, Therrien, Bell, Dill," Flow Ace Gallery, Los Angeles, CA

"Art of The States: American Work After the Sixties," Santa Barbara Museum of Art, Santa Barbara, CA

"Currents," Institute of Contemporary Art, Boston, MA

"A Broad Spectrum: Los Angeles Contemporary Painters & Sculptors," The Design Center of Los Angeles, CA

"The Urban Landscape," One Market Plaza, San Francisco, CA

"Return of the Narrative," Palm Springs Desert Museum, Palm Springs, CA

"Crime and Punishment," Triton Museum of Contemporary Art, Santa Clara, CA

"California Sculptural Directions, 1984," Maple Gallery, San Diego, CA

"Anxious Interiors," Laguna Museum of Art, Laguna Beach, CA/Alaska Association for the Arts, Fairbanks, AK/Alaska State Museum, Juneau, AK/Visual Arts Center of Alaska, Anchorage, AK/Walter Phillips Gallery, Banff, Alberta, Canada/Visual Arts Gallery, Florida International University, Miami, FL/University of South Florida, Tampa, FL/Munson-Williams, Proctor Institute, Utica, NY

1983

"The House That Art Built," California State University, Fullerton, CA

"Adult Fairy Tales," (One person exhibition), Flow Ace Gallery, Los Angeles, CA

"Cultural Excavations: Recent and Distant," Japanese American Cultural and Community Center, Los Angeles, CA

"Day In–Day Out," Freedman Gallery, Albright College, Redding, PA

"Construction," Connector Gallery, San Francisco International Airport, San Francisco, CA

"L.A. Seen," Frederick S. Wight Gallery, University of California, Los Angeles, CA

"Selections II," Fuller Goldeen Gallery, San Francisco, CA

1982

"documenta 7," Kassel, Germany

"Imaginative Sculpture," Gallery at the Plaza, Security Pacific National Bank Los Angeles, CA

"Microcosms From California," Santa Barbara Museum of Art, Santa Barbara, CA

"100 Years of California Sculpture," Oakland Museum, Oakland, CA

"20 American Artists: Sculpture, 1982," San Francisco Museum of Modern Art, San Francisco, CA

"Forgotten Dimension," Fresno Arts Center, Fresno, CA

1981

"The Museum as Site: Sixteen Projects," Los Angeles County Museum of Art, Los Angeles, CA

"Humor in Art," Los Angeles Institute of Contemporary Art, Los Angeles, CA

One person exhibition, Pittsburgh Art Center, Pittsburgh, PA

"The Castle of Perseverance," Palomar College, San Marcos, CA

"The Intimate Object," The Downtown Gallery, Los Angeles, CA

"Small Scale Sculpture," Sonoma State College, Sonoma, CA

1980

"Sculpture in California, 1975–80," San Diego Museum of Art, San Diego, CA

"Architectural Sculpture," Mount Saint Mary's College, Los Angeles, CA

"Tableaux," Middendorf-Lane Gallery, Washington, D.C.

One person exhibition, Flow Ace Gallery, Venice, CA

One person exhibition, Ace Gallery, Vancouver, B.C., Canada

"Architectural Sculpture," Los Angeles Institute of Contemporary Art, Los Angeles, CA

"Small Scale Sculpture," Los Angeles Municipal Art Gallery, Barnsdall Park, Los Angeles, CA

1979

"Directions," Hirshhorn Museum, Washington, D.C.

"Los Angeles in the Seventies," Norton Gallery, West Palm Beach, FL

"Visual Musical Permutations," University of California, Irvine, CA

1978

One person exhibition, South Alberta Art Gallery, Lethbridge, Alberta, Canada

One person exhibition, Calgary Museum, Calgary, Alberta, Canada

"Miniature Narratives," University of California, San Diego, CA

"Rooms, Moments Remembered," Newport Harbor Art Museum, Newport Beach, CA

1977

One person exhibition, Los Angeles County Museum of Art, Los Angeles, CA

One person exhibition, Cirrus Gallery, Los Angeles, CA

"Los Angeles in the Seventies," The Fort Worth Museum, Fort Worth, TX

"Photographs by Southern California Painters and Sculptors," University of California, Santa Barbara, CA

One person exhibition, California State University, Chico, CA

"Miniature," California State University, Los Angeles, CA

"Private Images: Photographs by Sculptors," Los Angeles County Museum of Art, Los Angeles, CA

1976

"Painting and Sculpture in California: The Modern Era," The Smithsonian Institution, Washington, D.C./San Francisco Museum of Modern Art, San Francisco, CA/National Collection of Fine Art, Washington, D.C.

"Imagination," Los Angeles Institute of Contemporary Art, Los Angeles, CA

"Drawings," Santa Barbara Museum of Art, Santa Barbara, CA

"Attitudes," California State University, Los Angeles, CA

One person exhibition, Southwest Texas State University, San Marcos, TX

1975

Whitney Museum Biennial Exhibition, New York, NY

"Masterworks in Wood," Portland Museum, Portland, OR

"Private Spaces," Fine Art Gallery, University of California, Irvine, CA

1974

"Three Dimensional Word Works," San Jose State College, San Jose, CA

"American Drawing," Eastern Washington State College, Cheney, WA

Selected Bibliography

1991

Josine Ianco Starrels, *Individual Realities* (catalog). Sezon Museum of Art, Tokyo, Japan, 1991.

1990

Mary Davis MacNaughton, *Crossing the Line: Word and Image in Art, 1960–1990* (catalog). Galleries of the Claremont Colleges, Claremont, CA, 1990.

Kathy Register, "Art in Defense of the Planet." *Pasadena Star News*, March 2, 1990.

William Wilson, "The Word's The Thing at Pomona." *Los Angeles Times*, September 5, 1990.

1989

Ann M. Fitzgibbons, *Portraits: Here's Looking at You* (catalog). Anchorage Museum of History and Art, Anchorage, AK, 1989.

Buzz Spector, "Roland Reiss: At Large Among Giants." *Los Angeles Magazine*, February 1989.

1988

Cathy Curtis, "The Galleries." *Los Angeles Times*, July 8, 1988.

Kim Levin, *Beyond Modernism, Essays on Art from the 70s & 80s*. New York: Harper & Row, 1988.

Sandra Leonard Starr, *Lost and Found in California, Four Decades of Assemblage Art* (catalog). Shoshana Wayne and James Corcoran Galleries, Santa Monica, CA, 1988.

1987

Kenneth Baker, "Sculptor Reiss Is Playful in His 'Ball Game'." *San Francisco Chronicle*, August 20, 1987.

Sandy Ballatore, "Avant Garde in the Eighties?" *Visions Magazine,* Fall 1987.

Howard Fox, *Avant Garde in the Eighties* (catalog). Los Angeles County Museum of Art, Los Angeles, CA, 1987.

Katherine Hough, *California Figurative Sculpture* (catalog). Palm Springs Desert Museum, Palm Springs, CA, 1987.

Ying Ying Lai, *Contemporary Southern California Art* (catalog). Taipei Fine Arts Museum, Taipei, Japan, 1987.

Suzanne Muchnic, "The Way We Are, Figuratively." *Los Angeles Times,* March 3, 1987.

Mark Van Proyen, "A Cryptographer's Delight." *Artweek,* August 8, 1987.

William Wilson, "Eye to Eye with the Avant Garde." *Los Angeles Times,* May 3, 1987.

1986

Peter Clothier, "Roland Reiss at Flow Ace Galley." *L.A. Weekly,* March 28, 1986.

Mark Elliot Lugo, "Interior: The Home—Exterior: The Landscape." *San Diego Tribune,* November 1986.

Merle Schipper, "Los Angeles Reviews: Roland Reiss at Flow Ace." *ARTnews,* Summer 1986.

William Wilson, "The Art Galleries." *Los Angeles Times,* March 21, 1986.

1985

Robert Egelston, "Creative Stewardship: Extending the Horizons of Corporate Art Collecting." *Connections*, Vol. 1, Number 1, 1985.

Ralph H. Kilman, "Corporate Culture." *Psychology Today,* April 1985.

Tressa Ruslander Miller, *California Painting and Sculpture from the Collection of the Capital Group* (catalog). Gallery at the Plaza, Security Pacific National Bank, Los Angeles, CA, 1985.

Joseph Young, "Hockney, Reiss: Unique Artists." *Scottsdale Daily Progress,* January 11, 1985.

1984

Linda Bellon, "A Functional, Nonfunctional Overload." *Artweek*, October 13, 1984.

Elaine Dine, *Anxious Interiors* (catalog). Laguna Beach Museum, Laguna Beach, CA, 1984.

Jo Farb Hernandez, *Crime and Punishment* (catalog). Triton Museum of Art, Santa Clara, CA, 1984.

Elsie Miller, "Larger than Life." *San Diego Magazine*, February 1984.

Suzanne Muchnic, "High Anxiety at The Laguna Beach Museum." *Los Angeles Times,* January 18, 1984.

Linda Yuskaitis, "Twenty-eight Artists." *The Orange County Register,* January 17, 1984.

1983

Tricia Crane, "Fairy Tales are True." *The Daily News*, April 29, 1983.

Dextra Frankl, *The House That Art Built* (catalog). California State University, Fullerton, CA, 1983.

Carter Radcliff, *Day In/Day Out* (catalog). Freedman Gallery, Albright College, Redding, PA, 1983.

Ruth Weisberg, "Tales of the Corporate World." *Artweek,* May 14, 1983.

1982

Roger Bolomey, *Forgotten Dimension* (catalog). Fresno Art Center, Fresno, CA, 1982.

Frank Cebulski, "Sculpture as a Mirror for Life." *Artweek,* August 14, 1982.

Pamela Hammond, "Forums in Space." *Images and Issues,* November/December 1982.

Tressa Ruslander Miller, *Imaginative Sculpture* (catalog). Gallery at the Plaza, Security Pacific National Bank, Los Angeles, CA, 1982.

Riorella Minervino, "Kassel, Questa Pittura e un tigre di carta." *Corriere Della Sera,* June 27, 1982.

George W. Neubert, *20 American Artists: Sculpture 1982* (catalog). San Francisco Museum of Modern Art, San Francisco, CA, 1982.

Christina Orr-Cahill, *100 Years of California Sculpture* (catalog). The Oakland Museum, Oakland, CA, 1982.

Robert L. Pincus, "Bay Area: Sculpture Shows." *Los Angeles Times,* July 25, 1982.

Marina Vaizey, "The Jokers who are having fun with Modern Art." *London Times,* June 27, 1982.

William Wilson, "Sculpture: California Dreaming." *Los Angeles Times,* August 19, 1982.

Pete Winter, "Phantasie aus dem Lamde Liliput." *das kunstwerk,* August 1982.

1981

Stephanie Barron, *Museum as Site: Sixteen Projects* (catalog). Los Angeles County Museum of Art, Los Angeles, CA, 1981.

Jean-Luc Bordeaux, "Los Angeles, a New Center for Contemporary Art." *Connaissance des Arts,* November 1981.

Amy Chu, "Tiny Tableaux." *The San Diego Reader*, December 10, 1981.

Joan Hugo, "Los Angeles Survey: Oversight and Overreach." *Artweek,* September 26, 1981.

William Spurlock, *Roland Reiss, Psychosocial Environments* (catalog). Santa Barbara Museum of Art, Santa Barbara, CA, 1981.

Clare White, "Roland's Room." *San Diego Magazine*, December 1981.

Don Woodford, *Locations* (catalog). California State University, San Bernardino, 1981.

Melinda Wortz, "Art in Los Angeles, 17 Artists — 16 Projects." *ARTnews,* November 1981.

1980

Richard Armstrong, *Sculpture in California 1975–1980* (catalog). San Diego Museum of Art, San Diego, CA, 1980.

Sandy Ballatore, "Roland Reiss at Ace." *Art in America,* October 1980.

George Christy, "The Great Life." *The Hollywood Reporter,* February 5, 1980.

Hal Glicksman, *Furnishings by Artists* (catalog). Otis/Parsons Gallery, Los Angeles, CA, 1980.

Caroline Huber, *Tableaux, An American Selection* (catalog). Middendorf-Lane Gallery, Washington, D.C., 1980.

Suzanne Muchnic, "Sculpture Becomes a Structure." *Los Angeles Times,* October 27, 1980.

Merle Schipper, "Theaters of Vision." *Artweek,* February 16, 1980.

William Wilson, "The Start of a Decade of Promise." *Los Angeles Times,* December 28, 1980.

Diana Zlotnick, *Spatial Awareness/New Conceptual Boundaries* (catalog). Pierce College, Los Angeles, CA, 1980.

1979

Howard Fox, *Directions* (catalog). The Hirshhorn Museum, Washington, D.C., 1979.

Merle Schipper, "Roland Reiss in Conversation with Merle Schipper." *Visual Dialogue,* April/June 1979.

Howard Singerman, "Room-size Replications." *Artweek,* January 6, 1979.

Melinda Wortz, "Crawling Like Alice, Down the Rabbit Hole." *ARTnews,* January 1979.

1978

Stuart Greenspan, "Thirteen Sculptors at the Freidus Galley." *Art Forum,* October 1978.

Louise Lewis, "An Interview with Roland Reiss." *The Dumb Ox,* 1978.

Suzanne Muchnic, "Sculptors as Photographers." *Artweek,* February 1978.

Ida K. Rigby, "Intensification Through Diminution." *Artweek,* December 2, 1978.

Betty Turnbull, *Rooms, Moments Remembered* (catalog). Newport Harbor Art Museum, Newport Beach, CA, 1978.

1977

Ruth Askey, "Contemporary Miniatures." *Artweek,* October 22, 1977.

Stephanie Barron, *Roland Reiss, The Dancing Lessons: 12 Sculptures* (catalog). Los Angeles County Museum of Art, Los Angeles, CA, 1977.

Peter Clothier, "Magic of the Possible." *Art Forum,* April 1977.

Henry Hopkins, *Painting and Sculpture in California, The Modern Era* (catalog). San Francisco Museum of Modern Art, San Francisco, CA, 1977.

Janet Kutner, "Dallas/Fort Worth/Los Angeles in the Seventies." *ARTnews,* December 1977.

William Wilson, "Soft-Core Tableaux from a New Kid." *Los Angeles Times,* June 5, 1977

William Wilson, "Artists' Views on Works in Miniature." *Los Angeles Times,* November 31, 1977.

1976

Alfred Frankenstein, "New Realism's Dramatic Freshness in the 'Modern' Era." *San Francisco Examiner and Chronicle,* October 3, 1976.

Kim Levin, "Narrative Landscape on the Continental Shelf: Notes on Southern California." *Arts Magazine,* October 1976.

1975

Martha Alf, "Insight into Creativity." *Artweek,* November 22, 1975.

Judy Crook, "Integrity of the Phenomenon: The Magic Worlds of Larry Albright and Roland Reiss." *LAICA Journal,* November 1975.

Jesse Jacobs, *Word Works Two* (catalog). San Jose State University, 1975.

Josine Ianco Starrels, *Impetus, The Creative Process* (catalog). Los Angeles Municipal Art Gallery, Barnsdall Park, Los Angeles, CA, 1975.

William Wilson, "Medium Mingles with Messages." *Los Angeles Times,* October 20, 1975.

Melinda Wortz, *Private Spaces, An Exhibition of Small Scale Sculpture* (catalog). University of California, Irvine, CA, 1975.

Los Angeles Municipal Art Gallery

AT BARNSDALL ART PARK

Fellows of Contemporary Art

The concept of the Fellows of Contemporary Art as developed by its founding members is unique. We are an independent organization established in 1975. Monies received from dues are used to underwrite our exhibitions, catalogs and videos at tax-exempt museums and galleries which have their focus in the field of contemporary art. We do not give grants, sponsor fundraising events, maintain a permanent facility or collection. In addition to the exhibition schedule, the Fellows have an active membership education program.

1976

Ed Moses Drawings 1958–1976

Frederick S. Wight Art Gallery
University of California, Los Angeles
Los Angeles, CA
July 13–August 15, 1976
Catalog with essay by Joseph Masheck.

1977

Unstretched Surfaces/Surfaces Libres

Los Angeles Institute of
Contemporary Art
Los Angeles, CA
November 5–December 16, 1977
Catalog with essays by Jean-Luc
Bordeaux, Alfred Pacquement,
and Pontus Hulten.
Artists: Bernadette Bour, Jerrold
Burchman, Thierry Delaroyere, Daniel
Dezeuze, Charles Christopher Hill,
Christian Jaccard, Allan McCollum,
Jean-Michel Meurice, Jean-Pierre
Pincemin, Peter Plagens, Tom Wudl,
Richard Yokomi

1978–80

Wallace Berman Retrospective

Otis Art Institute Gallery
Los Angeles, CA
October 24–November 25, 1978
Catalog with essays by Robert Duncan
and David Meltzer. Supported by a
grant from the National Endowment
for the Arts, Washington, D.C., a
federal agency. Exhibition traveled to:
Fort Worth Art Museum, Fort Worth,
TX; University Art Museum,
University of California, Berkeley, CA;
Seattle Art Museum, Seattle, WA.

1979–80

Vija Celmins,

A Survey Exhibition

Newport Harbor Art Museum
Newport Beach, CA
December 15, 1979 – February 3, 1980
Catalog with essay by Susan C. Larsen.
Supported by a grant from the
National Endowment for the Arts,
Washington, D.C., a federal agency.
Exhibition traveled to: The Arts Club
of Chicago, Chicago, IL; The Hudson
River Museum, Yonkers, NY;
The Corcoran Gallery of Art,
Washington, D.C.

1980

Variations:

Five Los Angeles Painters

University Art Galleries
University of Southern California
Los Angeles, CA
October 20–November 23, 1980
Catalog with essay by Susan C. Larsen.
Artists: Robert Ackerman, Ed Gilliam,
George Rodart, Don Suggs, Norton
Wisdom

1981–82

Craig Kauffman

Comprehensive Survey

1957–1980

La Jolla Museum of Contemporary Art
La Jolla, CA
March 14–May 3, 1981
Catalog with essay by
Robert McDonald.
Supported by a grant from the
National Endowment for the Arts,
Washington, D.C., a federal agency.
Exhibition traveled to: Elvehjem
Museum of Art, University of
Wisconsin, Madison, WI; Anderson
Gallery, Virginia Commonwealth
University, Richmond, VA; The
Oakland Museum, Oakland, CA.

1981–82

Paul Wonner: Abstract Realist

San Francisco Museum of Modern Art
San Francisco, CA
October 1–November 22, 1981
Catalog with essay by
George W. Neubert.
Exhibition traveled to: Marion
Koogler McNay Art Institute, San
Antonio, TX; Los Angeles Municipal
Art Gallery, Los Angeles, CA.

1982–83

Changing Trends:

Content and Style

Twelve Southern California Painters
Laguna Beach Museum of Art
Laguna Beach, CA
November 18, 1982–January 3, 1983
Catalog with essays by Francis
Colpitt, Christopher Knight, Peter
Plagens, and Robert Smith.
Exhibition traveled to: Los Angeles
Institute of Contemporary Art,
Los Angeles, CA. Artists: Robert
Ackerman, Caron Colvin, Scott
Grieger, Marvin Harden, James
Hayward, Ron Linden, John Miller,
Pierre Picot, George Rodart, Don
Suggs, David Trowbridge, Tom Wudl

1983

Variations II:

Seven Los Angeles Painters

Gallery at the Plaza, Security Pacific
National Bank
Los Angeles, CA
May 8–June 30, 1983
Catalog with essay by
Constance Mallinson.
Artists: Roy Dowell, Kim Hubbard,
David Lawson, William Mahan, Janet
McCloud, Richard Sedivy, Hye Sook

1984

Martha Alf Retrospective

Los Angeles Municipal Art Gallery
Los Angeles, CA
March 6–April 1, 1984
Catalog with essay by
Suzanne Muchnic.
Exhibition traveled to: San Francisco
Art Institute, San Francisco, CA.

1985

Sunshine and Shadow: Recent Painting in Southern California

Fisher Gallery,
University of Southern California
Los Angeles, CA
January 15–February 23, 1985
Catalog with essay by Susan C. Larsen.
Artists: Robert Ackerman, Richard Baker, William Brice, Karen Carson, Lois Colette, Ronald Davis, Richard Diebenkorn, John Eden, Llyn Foulkes, Charles Garabedian, Candice Gawne, Joe Goode, James Hayward, Roger Herman, Charles Christopher Hill, Craig Kauffman, Gary Lang, Dan McCleary, Arnold Mesches, John M. Miller, Ed Moses, Margit Omar, Marc Pally, Pierre Picot, Peter Plagens, Luis Serrano, Reesey Shaw, Ernest Silva, Tom Wudl

1985

James Turrell

The Museum of Contemporary Art
Los Angeles, CA
November 13, 1985–February 9, 1986
A book entitled *Occluded Front James Turrell* was published in conjunction with the exhibition.

1986

William Brice

The Museum of Contemporary Art
Los Angeles, CA
September 1–October 19, 1986
Full color catalog with essay by Richard Armstrong. Exhibition traveled to: Grey Art Gallery and Study Center, New York University, New York, NY.

1987

Variations III: Emerging Artists in Southern California

Los Angeles Contemporary Exhibitions
Los Angeles, CA
April 22–May 31, 1987
Catalog with essay by Melinda Wortz.
Exhibition traveled to: Fine Arts Gallery, University of California, Irvine, CA; and Art Gallery, California State University, Northridge, CA.
Artists: Alvaro Asturias/John Castagna, Hildegarde Duane/David Lamelas, Tom Knechtel, Joyce Lightbody, Julie Medwedeff, Ihnsoon Nam, Ed Nunnery, Patti Podesta, Deborah Small, Rena Small, Linda Ann Stark

1987–88

Perpetual Motion

Santa Barbara Museum of Art
Santa Barbara, CA
November 17, 1987–January 24, 1988
Catalog with essay by Betty Turnbull.
Artists: Karen Carson, Margaret Nielsen, John Rogers, Tom Wudl

1988–89

Jud Fine

La Jolla Museum of Contemporary Art
La Jolla, CA
August 19–October 2, 1988
Catalog with essays by Ronald J. Onorato and Madeleine Grynstejn.
Exhibition traveled to: de Saisset Museum, Santa Clara University, Santa Clara, CA.

1989–90

The Pasadena Armory Show 1989

The Armory Center for the Arts
Pasadena, CA
November 2, 1989–January 31, 1990
Catalog with essay by Dave Hickey, and curatorial statement by Noel Korten.
Artists: Carole Caroompas, Karen Carson, Michael Davis, James Doolin, Scott Grieger, Raul Guerrero, William Leavitt, Jerry McMillan, Michael C. McMillen, Margit Omar, John Outterbridge, Ann Page, John Valadez

1990

Lita Albuquerque: Reflections

Santa Monica Museum of Art
Santa Monica, CA
January 19–April 1, 1990
Catalog with essay by Jan Butterfield, and interview with curator, Henry Hopkins and Lita Albuquerque.

1991–92

Facing the Finish: Some Recent California Art

San Francisco Museum of Modern Art
San Francisco, CA
September 20–December 1, 1991
Catalog with essay by John Caldwell and Bob Riley. Exhibition traveled to: Santa Barbara Contemporary Arts Forum, Santa Barbara, CA and Art Center College of Design, Pasadena, CA. Artists: Nayland Blake, Jerome Caja, Jim Campbell, David Kremers, Rachel Lachowicz, James Luna, Jorge Pardo, Sarah Seager, Christopher Williams, Millie Wilson

Video Series: Videos are produced and directed by Joe Leonardi, Long Beach Museum of Art Video Annex, for the Fellows of Contemporary Art.

"Red is Green: Jud Fine," 1988

"Horace Bristol: Photojournalist," 1989

"Altering Discourse: The Works of Helen and Newton Harrison," 1989

"Frame and Context: Richard Ross," 1989

"Experience: Perception, Interpretation, Illusion (The Pasadena Armory Show 1989)," 1989

"Secrets, Dialogs, Revelations: The Art of Betye and Alison Saar," 1990

"Lita Albuquerque: Reflections," 1990

"Los Angeles Murals," 1990

"Stretching the Canvas," Compilation tape narrated by Peter Sellars, 1990

"Michael Todd: Jazz," 1990

Board of Directors

Virginia C. Krueger
Chairman

Susan Caldwell
Vice Chairman

Donna Mills
Secretary

Alfred H. Hausrath III
Treasurer

Catherine Partridge
Chairman, Long Range Exhibition Planning

Anne Lasell
Chairman, Program/Education

Gordon F. Hampton
Chairman, Research and Fund Development

Penny Lusche
Chairman, Tours

Gloria Kamm
Chairman, Curators' Showcase

Sandra Talcott
Chairman, Membership

Julie Masterson
Chairman, Updates

Barbara Cohn
Chairman, Publicity

Louise Newquist
Chairman, Special Events

Gerald Buck
Member

Kay Files
Member

Mickey Gribin
Member

Standish Penton
Member

Russel I. Kully
Immediate Past Chairman

Alice Rotter
Administrative Director

Past Fellows Chairmen

Martha Bertonneau Padve 1976, 1977
Murray A. Gribin 1978, 1979
Nancy Dau Yewell, 1980, 1981
David H. Steinmetz 1982
Gordon F. Hampton 1983, 1984
Peggy Phelps 1985, 1986
George N. Epstein 1987, 1988
Russel I. Kully 1989, 1990

Roster of Members

Judith M. Adelson
Eleanor A. Alkire
Mr. and Mrs. Dean V. Ambrose
Mr. and Mrs. Anthony Antoville
Mr. and Mrs. Charles S. Arledge
Mr. and Mrs. Thomas Armstrong
Mr. and Mrs. Robert S. Attiyeh
Mrs. Antoinette Ayres
Ms. Virginia Lee Babbitt
Mr. and Mrs. Walter Baer
Mr. and Mrs. Joseph L. Baker
Mr. and Mrs. Eaton W. Ballard
Mr. Gregg Barr
Mr. and Mrs. Olin Barrett
Mrs. B. J. Beaumont
Mr. Geoffrey C. Beaumont
Dr. and Mrs. Selden Beebe
Mr. and Mrs. Lazare F. Bernhard
Dr. and Mrs. Robert L. Boardman
Mr. and Mrs. Gordon Bodek
Dr. and Mrs. Vernon C. Bohr
Dr. and Mrs. George Boone
Ms. Joan N. Borinstein
Mr. and Mrs. David A. Boss
Mr. and Mrs. Steven Robert Boyers
Mr. and Mrs. John Brinsley
Ms. Linda Brownridge and
Mr. Edward Mulvaney
Mr. and Mrs. Ernest A. Bryant III
Mr. and Mrs. Gerald E. Buck
Ann Burke
Mrs. Betye Burton
Mr. and Mrs. John Caldwell
Mr. and Mrs. Timothy C. Cameron
Mr. and Mrs. Robert Carlson
Dianne Carr

Dr. and Mrs. Arthur N. Chester
Ms. Barbara Cohn
Mr. and Mrs. Michael A. Cornwell
Mr. and Mrs. James A. Cross
Mr. and Mrs. Timm F. Crull
Mrs. James H. Dean
Mr. and Mrs. Charles J. Diamond
Mr. and Mrs. James F. Dickason
Mr. and Mrs. John T. Driscoll
Mr. and Mrs. Brack W. Duker
Mr. and Mrs. William H. Eager
Mr. and Mrs. Clifford J. Einstein
Mr. and Mrs. George N. Epstein
Mrs. Helen J. Epstein
Mrs. Marvin L. Faris
Mr. and Mrs. Donald G. Farris
Mrs. Jack M. Farris
Mr. and Mrs. Eugene Felder
Mrs. Elliott Field
Hon. and Mrs. Gordon L. Files
Mr. and Mrs. Merrill R. Francis
Mrs. Betty Freeman
Mr. Fritz Geiser
Mrs. Karen A. Girardi
Mr. and Mrs. Richard Gold
Mr. and Mrs. Robert H. Grant
Mr. and Mrs. Arthur N. Greenberg
Mr. and Mrs. Bernard A. Greenberg
Mr. and Mrs. James C. Greene
Mr. and Mrs. Murray A. Gribin
Mr. and Mrs. Foster Hames
Mr. Gordon F. Hampton
Mr. and Mrs. Eugene Hancock
Dr. and Mrs. Alfred H. Hausrath III
Mr. and Mrs. Thomas Hollingsworth
Mr. and Mrs. John F. Hotchkis
Mr. and Mrs. Stirling L. Huntley
Mr. and Mrs. William H. Hurt
Mr. and Mrs. Jerome Janger

Mr. and Mrs. Lambert M. Javelera
Mr. and Mrs. E. Eric Johnson
Mr. and Mrs. Jerry W. Johnston
Mr. and Mrs. Solomon M. Kamm
Mr. and Mrs. Robert Keilly
Mr. and Mrs. John C. Kennady
Virginia C. Krueger
Mr. and Mrs. Russel I. Kully
Dr. and Mrs. Gerald W. Labiner
Mr. and Mrs. Sidney Landis
Mr. and Mrs. Nahum Lainer
Dr. and Mrs. Eldridge L. Lasell
Mr. and Mrs. Hoyt Leisure
Mr. and Mrs. Charles M. Levy
Linda L. Lund
Dr. and Mrs. John E. Lusche
Mr. and Mrs. Leon Lyon
Sylvia Mandigo
Mr. and Mrs. Brian L. Manning
Mr. and Mrs. Robert T. Martinet, Jr.
Hon. and Mrs. William Masterson
Mr. and Mrs. J. Terry Maxwell
Mr. and Mrs. Vincent J. McGuinness
Mr. and Mrs. James McIntyre
Mr. and Mrs. Frederick McLane
Mr. and Mrs. Philip H. Meltzer
Mr. & Mrs. Walter Meyer
Ms. Jeanne Meyers
Mrs. Alathena Miller
Mr. and Mrs. Charles D. Miller
Mr. and Mrs. Gavin Miller
Mr. and Mrs. Clinton W. Mills
Mr. D. Harry Montgomery
Anne Marie Moses
Sally E. Mosher
Mr. and Mrs. George Nagler
Dr. and Mrs. Robert M. Newhouse
Dr. and Mrs. Richard E. Newquist
Mr. and Mrs. Frederick M. Nicholas

Mr. and Mrs. James W. Obrien
Dr. and Mrs. Giuseppe Panza di
Biumo
Mr. and Mrs. David B. Partridge
Mr. and Mrs. Theodore Paulson
Ms. Joan A. Payden
Mr. and Mrs. J. Blair Pence II
Mr. and Mrs. Standish K. Penton
Mr. and Mrs. Frank H. Person
Peggy Phelps
Dr. and Mrs. Reese Polesky
Mr. and Mrs. M.B. Preeman
Mr. and Mrs. David Price
Mr. and Mrs. Lawrence J. Ramer
Mr. and Mrs. Charles C. Read
Kathleen Reges and Richard Carlson
Mrs. Joan B. Rehnborg
Mr. and Mrs. Bernard Ridder, Jr.
Mr. and Mrs. Chapin Riley
Dr. and Mrs. Armin Sadoff
Ms. Ramona A. Sahm
Mr. and Mrs. Barry A. Sanders
Mr. and Mrs. Fred Schoellkopf
Mrs. June W. Schuster
Mr. and Mrs. J.C. Schwarzenbach
Mr. and Mrs. David C. Seager, III
Dr. and Mrs. Garland Sinow
Mr. and Mrs. George Smith
Mr. and Mrs. Russell Dymock Smith
Mr. and Mrs. Howard Smits
Mr. William R. Solaini
Mr. and Mrs. Milton R. Stark
Ms. Laurie Smits Staude
Mr. and Mrs. David H. Steinmetz

Mr. and Mrs. George E. Stephens, Jr.
Dr. and Mrs. Jason H. Stevens
Mr. and Mrs. Richard L. Stever
Joan Stewart
Elaine Stone
Mrs. Ann E. Summers
Mr. and Mrs. Robert M. Talcott
Mr. and Mrs. Dennis Tani
Mr. and Mrs. Stanford H. Taylor
Dr. and Mrs. Don Thomas
Mr. and Mrs. Joseph Tom
Mr. and Mrs. Erwin Tomash
Mr. and Mrs. James R. Ukropina
Jolly Urner
Mr. and Mrs. Robert D. Volk
Mr. and Mrs. Frederick R. Waingrow
Corinne Whitaker and Michael
Sheedy
Mr. and Mrs. George F. Wick
Mr. and Mrs. Toby Franklin K.
Wilcox
Mrs. James Williams Wild
Mr. and Mrs. John H. Wilke
Mr. and Mrs. Richard A. Wilson
Mr. and Mrs. Eric Wittenberg
Mr. and Mrs. Robert J. Woods, Jr.
Mr. and Mrs. Paul K. Yost, III
Mrs. Billie K. Youngblood
Mr. Robert L. Zurbach

Design

EILEEN AVERY
DESIGN CONSULTANTS

Photography

BREWER PHOTOGRAPHY

Contributing Photographers

R. GASS
PAGE 45: LEFT

ACE CONTEMPORARY
EXHIBITIONS
PAGE 71: LEFT

RICHARD INGRAM
PAGE 82, 83

PASADENA CITY COLLEGE
PAGE 84, 85

*This book was
set in Garamond
and Univers.
2,400 copies printed
on Vintage Velvet
by Typecraft, Inc.*